To Helen.

CRAVAT
& TIE PINS

PAST AND PRESENT

With best wishes

James Gosling.

JAMES G. GOSLING

Published by
James G. Gosling

First published 2017
First edition limited to 250 copies

A catalogue of this book is available from the British Library
ISBN 978-1-5262-0680-0

Published and distributed by
Bower Parnham Stewart
Trinity House
Linby, Nottingham NG15 8AA

Printed and produced by
Galloways

Front cover illustrations:
Butterfly cravat pin, c.1780 (page 20)
Horse cravat pin, c.1840 (page 30)
Prince Albert tie pin, c.1861 (page 38)
Wasp tie pin, c.1910 (page 59)
Concorde tie pin, c.1990 (page 80)

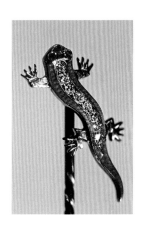

Dedicated to the memory
of my great friend
John,
a fellow enthusiast

Acknowledgements

I should like to thank my friends in various Museums in London and countrywide, The Gemmological Association, The Society of Jewellery Historians, Librarians, Auction Houses and the many dealers at Antique Fairs, who have all offered me so much help and advice over the years. I have also spoken to many collectors interested in jewellery whom I have not been able to mention individually. I can only extend to you my sincere thanks, for without your help and interest I could never have completed this work.

In particular, may I thank those close friends who have supported me with photography, undertaking impossible repairs, proof reading and encouragement. My sincere appreciation to Margot Arthurton, John Benjamin, Tony and Dörte Clayton, Gwyn Green, Norman Halls, Alan Jobbins, Doug Morgan, Clare Phillips, Michael (Spike) Walker and my designer Neil Foster.

The photography was carried out by Alan Jobbins, Michael (Spike) Walker and the author, together with historical images from Art Galleries and Museums that are as acknowledged.

Lastly, I should like to thank my dear wife Elizabeth, who has given me so much practical help, encouragement and support in the production of this book, together with my Father and Mother, who were a major source of inspiration.

Preface

It is not often that one comes across an item of jewellery that has not been studied in depth but is mentioned in some of the excellent pocket publications for collectors. There appears to have been comparatively little research into the history and development of cravat and tie pins, although most jewellery historians do give these items of mostly male jewellery, some coverage.

I still wear my grandfather's tie pins, but as fashions changed and became less formal the wearing of a tie pin has almost disappeared. However, there are signs that cravat and tie pins still hold plenty of interest for the collector and are increasingly offered for sale at Auction Houses.

Many tie pins were made from a remaining earring, a small brooch, an interesting button, a small miniature or an archaeological bead. Conversely, many very beautiful tie pins were made into rings or brooches.

The cravat and tie pins made by our greatest craftsmen remain masterpieces of the jewellers' art and design.

Pins with ornamental finials have been in existence since long before the Pharaohs and this illustrated work endeavours to reveal their fascinating history and development.

The social history and development of the cravat pin covers more than 7000 years. To understand the full significance of ordinary dressing and decorative pins it is also necessary to consider the manufacture of cloth, its type, and the development of clothing and accessories.

As the human race developed clothing, there was an obvious need to hold garments together by the use of a simple belt, large pin, buttons, hooks and, as the centuries passed, all the many devices of the present day. As cloth became very fine, pins were developed to hold veils and ruffs in fixed positions. Indeed, a ruff may have needed as many as 150 to 200 pins to hold it in position.

In the 18th Century, for example, the beautiful fine lace, lawn and silks would have needed pins that were lighter, smaller and thinner than in previous centuries, to hold these delicate, fine fabrics in place. This would have led to the use of pins with decorated heads in precious metals for the wealthy, and pins in base metals for the general population. The dimensions of cravat and tie pins varied, with early Georgian cravat pins with the zigzag stems being some 50mm in length with a single stone or ornamental finial. Whereas most later tie pins with a twist in the stem, were thicker and longer, on average 80mm, with decorative finials varying from a single stone to more ornate designs.

For a comparatively brief period of history, there came an incredible flowering of the most wonderful creations by talented craftsmen of ornamental cravat pins, and later tie pins, from around 1760 to the early 1930s – worn by both men and women.

The tie pins produced by Fabergé, Falize, Castellani, Giuliano, Boucheron, Tiffany and Cartier are exceptional examples of jewellery making. Most jewellers during this period would have made pins of distinction.

Such was the demand by the young men in the 1870s that tie pins were mass produced by the toy makers of Birmingham to ensure that they could all have a gilded pin for a few pence to wear with their best suit on Sundays.

Trade catalogues of the Goldsmiths & Silversmiths Company, Mappin & Webb and others were available in the late Victorian period and all had pages showing tie pin designs available for purchase. In the Moore & Evans catalogue from Chicago, it was even possible to purchase a revolver from the Jewellery Section!

The use of ornamental tie pins gradually declined after the Great War of 1914-1918 with a brief resurgence during the 1920s and 1930s, but they have now all but disappeared. However, there are still a few men and women who see tie pins as wonderful creations.

In 1951 the English Scarf Pin Society was formed. The Chairman was known as the *'King Pin'*, the Secretary as the *'Lynch Pin'* and the Treasurer as the *'Safety Pin'*. Sadly, it was disbanded in 1965.

This illustrated book shows the chronological development and fascinating history of these unique, and somewhat neglected, items of jewellery.

An essential piece of equipment for the tie pin collector is a really fine hand lens – jewellers' loupe 10 X. (The Gemmological Association of Great Britain, 21 Ely Place, London, EC1N 6TD)

Index

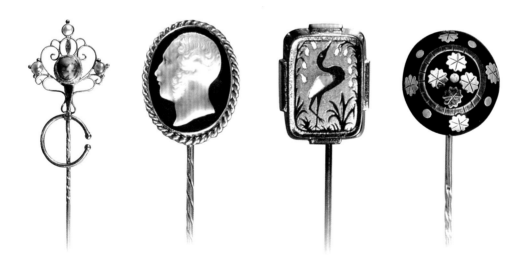

CHAPTER 1

Early Developments

Bronze Age – Roman – Anglo-Saxon – Medieval – Tudor – dressynge pins – portrait showing the use of pins – ornamental pins – Cravat brooch c.1775 with matching pin.

Over the immense period of human development the necessity of holding garments together, or items in a definite position on them, has led to the evolution of the pin. In ancient Egypt the Savannah tribes used copper alloy pins thousands of years before the pyramids were built. This information was revealed by researches for a programme made by Cicada Films in 2002 called *'The Secrets of the Sands'*, and shown on television. It is likely that the word *'pin'* is derived from the Latin *'spina'* meaning thorn and the Old English word *'pinna'* for quill.

'Pinned to a dress or cravat' is a masterpiece of understatement. The pins used were often of great creative and artistic merit, but have been largely forgotten in the historical study of jewellery. They existed in two forms: an inexpensive range for general use, usually made of bronze; the other, made of gold and silver for the aristocracy and the wealthy. Very inexpensive pins would have been carved from animal bone. Pins would have been worn by men and women and identified by their use: a cloak would have been held in place by a cloak pin, a cravat by a cravat or tie pin and so on. The length and thickness of the pin would have been determined by the type of fabric to be held in position. The use of the pin and the development of the buckle and catches used on clothing can be traced back over thousands of years. With the development of craftsmanship, pins were made with plain, simple or decorated heads which were fashioned from thorns, wood, jet, bone,

bronze, iron, silver or gold. It is useful to recall that Helen of Troy was a late Bronze Age Queen. Pins of the Bronze Age clearly show the artistic development of elegant decorated heads on pins of various lengths. These pins were made by drawing, forging, casting and carving; and later, some use was made of the lathe. Some pins, because of the extreme undercutting, may have been made by the lost wax method, e.g. Wessex bulb headed pins (early Bronze Age 200 to 500 BC).

In the Roman period pins were made from copper alloys and, for the wealthy from precious metals. There is now a clear division between bronze pins, cheaply-made on a large scale, and quality pins which were fewer in number and made by craftsmen using precious metals for high-status members of society. Quality pins were individually made, often with ornamental heads. Cheaper pins were produced in large numbers and were very simple in form.

During the Anglo Saxon and Norman periods, pins were made to suit the various types of cloth in use, but as the centuries passed, dress pins became lighter as fabrics became more delicate. By the 12th Century, pins in iron and copper alloys were being produced in huge quantities and, in 1356 a Guild of Pinners was established in London, and in 1407 a similar body in Bristol.

Edward III is said to have given 12,000 pins for veils to his daughter Princess Joan, who was contracted to be married in 1348. Joan left England in August 1348 to marry Peter of Castille, son of Alphonso XI of Castille and Maria of Portugal, but sadly, on her journey she contracted the plague *(Black Death)* and died in September 1348 near Bordeaux. Elizabeth of York, wife of Henry VII is recorded as having bought 300 pins for 4d, and in October 1563 Queen Elizabeth I ordered 121,000 pins. Charles I spent £500 a year on his wife Henrietta Maria to *'maintain her in sufficiency'*. How many pins were bought is not recorded, but at 300 for 4d in 1563 it may have been many thousands. It has been recorded that at her coronation Queen Victoria was almost encased in pins to hold her dress and jewellery in position.

During the 14th Century, new materials and changes in fashion had led to an enormous increase in the use of pins and to significant changes in manufacturing methods. Dressing pins became finer as wire was drawn to thinner diameters, but the overall types then hardly altered until the 18th Century.

From the 15th Century onwards the workforce involved in pin making consisted mainly of women and children, the old and sick. Some soldiers returning from wars who had suffered injuries were also employed. They all worked extremely long hours for very low wages.

Dressing or *'dressynge'* pins were used in great quantities for the fixing of all types of garments, including cravats. In 1587 almost three million pins were imported into London from the Netherlands. English pin makers found they were unable to produce the quantity and variety needed, nor could they compete with the cheaper price offered by Dutch makers. The Rate Books at that time show that, although iron and copper alloy pins had been made in

England since the late 13th Century, some *'23,473 dozen, thousand, worth £4,693' were received in London in the year from Michaelmas 1587 (23,473 x 12 x 1,000 = 281,676,000) and similar quantities had been imported during the 15th Century'*. (Research by Hazel Forsyth of the Museum of London).

Pin making was an industry that required the hand and eye skills of many different craftsmen, who worked in co-operation, to produce the finished product.

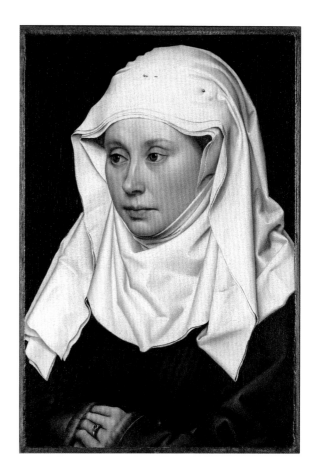

FIG 8 *Portrait of a Lady*, c.1430, by Robert Campin, showing the use of pins. © National Gallery, London. (NG 653.2)

The brass wire needed was pulled through dies or draw plates. One end of the shank was reduced in size and a turn of wire placed on this end. The pin would then have been held in a metal vice and a ram or heavy weight dropped on the head to spread the metal and hold the head in place. The other end of the shank was then sharpened by holding it in a groove cut in a piece of cow bone, which acted as a vice, and filing it to a sharp point. The heads of better pins were soldered to prevent them from working loose.

Adam Smith, the 18th Century founder of the science of political economy, who wrote 'The Wealth of Nations' published in 1776, considered pin making to be the classic example of the 'division of labour'. This could involve as few as six workers, but there may have been as many as twenty-five if the work processes were sub-divided. This division was somewhat similar to that of the jewellery trade where an article is created by a number of skilled individuals dividing up the work processes, (for example: designing, mounting, setting and polishing) in order to produce the finished item.

It was the fifth wife of Henry VIII, Catherine Howard, who introduced brass pins from France in the latter half of the 16th Century, and a monopoly was granted in 1565 for mining calamine (Smithsonite – zinc carbonate) in Somerset to make brass wire. Calamine was the essential source of zinc which, together with copper, was used to manufacture brass. Henry VIII also brought in a Statute (PRO Statute 37 Henry VIII cap.13) stating that "pins could not be sold unless they be double headed and the heads soldered fast to the shank of the pinne - well smoothed, the shank well shaven, the point well and round filed, cauted (that is canted or bevelled) and sharpened".

This Statute was necessary as imported pins were often of poor quality and with heads that became loose.

Back in the Middle Ages the possession of precious jewellery was largely confined to the nobility and the Church. The Wars of the Roses, between 1399 and 1461, resulted in most of the lay jewellery being melted down or sold abroad to raise extra finance. Likewise, the Reformation disposed of many Ecclesiastical treasures. Thus the way was dramatically prepared for the secular revival of lay jewellery in the 16th Century. Increased wealth and the inordinate love of jewellery by Henry VIII (1491–1547) and Elizabeth I (1533–1603) made the Century one of the most prolific for jewellery in our history, with the humble pin holding some of these elaborate jewels and clothing in place.

The Reformation provides the dividing line between the Middle Ages and the modern world – the Medieval and post-Medieval periods. Reformation Day, 31 October 1517, was the day Martin Luther posted his Ninety-five Theses on the door of the church at Wittenberg in Germany. This date is generally regarded as the beginning of the Reformation and the start of a period of much greater simplicity and less ostentation.

In the 16th Century jewellery was for the most part solid and heavy in design, as shown by the jewellery designs of Hans Holbein. There was an increased importance in the use of enamel, and gemstones were more carefully cut to enhance their beauty and optical brilliance. Paste and poor colour gem stones had their colour enhanced by the use of coloured foils and coloured stains applied to the back of the stone. Clear or colourless paste stones were used to simulate diamond, and the sharp end, or culet, had a small dab of black pitch applied to increase internal reflection.

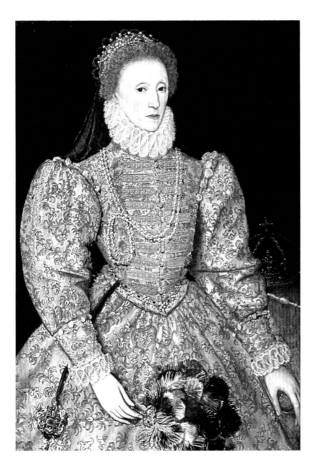

FIG 9 Portrait of Elizabeth I, showing how pins and/or stitching were used to hold elaborate necklaces in place. ©National Portrait Gallery, London. (NPG 2082)

However, the costumes of the lower classes were far less elaborate, verging on the primitive.

The effects of the Renaissance began to be felt at the end of the reign of Elizabeth I. The upper and middle classes became wealthier and the wearing of jewellery became more widespread. This brought about changes in jewellery styles: it became lighter and more gemstones were faceted. Pins were still used to hold an elaborate necklace in place, and often in a gravity-defying position.

By the time of James I in the early 17th Century the import bill for pins from abroad was £60,000 a year. A Protection Act was then passed forbidding the import of pins, except by the pinners themselves, in order to safeguard the British industry.

In England, in the 17th Century, the City of Gloucester became an important centre for pin making. Its rise is mainly attributed to one John Tilsley, who was given a grant by the City dignitaries in order to provide employment to those who had no other means of support. Although Gloucester no longer produces pins, the Folk Museum there has full details of the industry and a number of the early machines used in the manufacture of pins.

For the aristocracy, small dress pins and others of various lengths, were still used in immense quantities as some 200 pins were needed to hold a ruff in place around the neck. The ruff was made from a single length of starched cloth that was shaped with a goffering iron into a formal pleated collar. Pins also held together female costumes, including sleeves, cuffs, collars, aprons, veils, head-dresses and the stomacher was usually pinned to the sides of the front of the dress. Most dresses were pinned together, but undergarments would have been stitched.

From wardrobe accounts and paintings it is clear that pins were used for fastening veils and pinning the folds in linen head-dresses. Portraits often show that pins must have been used to hold necklaces and other dress ornaments in place on elaborate garments although small pins are rarely actually shown in the paintings.

Plain pins were made in vast quantities, but pins with decorative heads were produced in smaller numbers. Some were made with heads of coral, red jasper, glass and elaborate geometric facetted heads, or heads shaped in the form of acorns.

These acorns were particularly popular during the 17th Century and were also frequently represented in furniture, glass and architecture.

In the Jacobean and Restoration periods jewellery may have lacked the invention and fantasy of the Elizabethan era, but with increasing wealth of the merchant class jewellery became more universal, personal, small and dainty, as in the Cheapside Hoard *(c.1640)*, which may be seen in The Museum of London.

Gold would have been used to symbolise the enduring qualities of true love as it does not tarnish or lose its sheen. Gold is often referred to as *'the sweat of the sun'* and silver as *'the tears of the moon'*.

Ornamental pins at first, had only a small decorative head and zigzag stem, but gradually they became more elaborate in the stylised form of flowers, and increased both in length and size.

With the restoration of Charles II in 1660 members of his Court brought back to England, the cravat with its fashionable opportunities for display. This cravat was not like the later cravat of the early 18th Century which was associated with the dandies of that period, but before 1700 it was a delicate, lacy confection, usually held in place by a brooch and very small dress pins. Such cravats are exemplified by Grinling Gibbons in his amazing white lime wood carvings on display in the Victoria and Albert Museum.

It is interesting to note that in ancient China the neckcloth was popular, and the Terra Cotta Army of the first emperor Qin Shi Huangdi, discovered in 1974, all wore simple tied neckcloths.

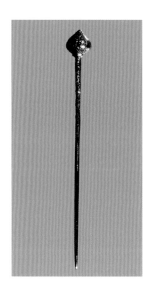

▲ **FIG 1** Bronze Age – *'Wessex'* bulb head pin (early) 200 to 500BC The head of the pin shows raised decoration.

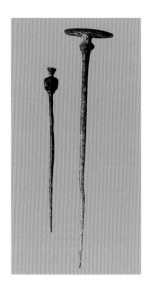

▲ **FIG 2** Two Bronze Age pins – one is 4¾" (121mm) and the other 3" (76mm) in length. (Helen of Troy was a Bronze Age Queen).

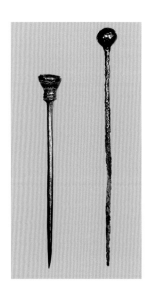

▲ **FIG 3** Two inexpensive Roman bronze pins.

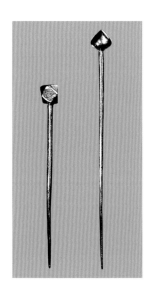

▲ **FIG 4** Two elegant, fine silver Roman pins.

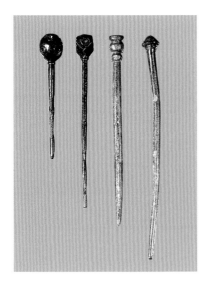

▲ **FIG 5** Anglo-Saxon pins – late Roman Anglo-Saxon, typical decoration 400AD.

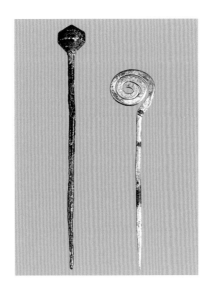

▲ **FIG 6** Pin of the 12th Century and a Tudor pin, showing the action of Thames water and mud on the copper in the alloy, when deprived of oxygen.

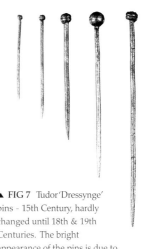

▲ **FIG 7** Tudor 'Dressynge' pins - 15th Century, hardly changed until 18th & 19th Centuries. The bright appearance of the pins is due to the action of Thames water, silt, mud and absence of oxygen. Millions of pins were used by men and women - some 200 were needed to secure a ruff in place. For more information, visit Gloucester Folk Museum which has machinery etc. to show how pins were made.

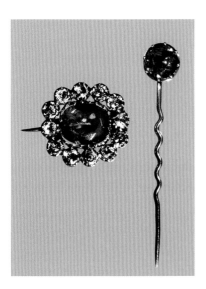

▲ **FIG 10** Cravat brooch and cravat pin of a similar blue green colour c.1770 – both made of paste, (which is coloured glass). This was a popular colour in Georgian times.

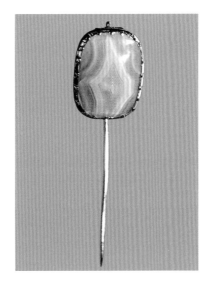

▲ **FIG 11** Gold cravat brooch - pink and white banded agate with C-shaped catch to hold pin in place.

▲ **FIG 12** Enlargement of the C-shaped catch (FIG 11).

CHAPTER 2

Cravat Pins of the late 18th Century and early 19th Century

Butterfly pin – French essay 1781 – Huntsman's process to produce tool steel 1740 – hair jewellery – memorial pin 1782 – sheep's wool spring – moss agate – paste – Ravenscroft – G F Strass – flower design – cut steel jewellery – rebus pins – language of stones.

The new soft style cravat, which made its appearance between the 1770s and 1780s, was made from a large square of muslin, lawn (fine cotton or linen) or silk. It was first folded into a triangle and refolded into a band which was passed around the neck starting from the front, crossed over at the back, then brought forward and knotted into a bow at the front. A pin would then be inserted to keep the folds in place. Clearly there were innumerable opportunities for variation in the tying of the cravat, and many a manservant became famous for his ability to tie a particular style – à la Byron, oriental, or mathematical.

The book *'Neckclothitania'*, written by J. J. Stockdale, and published in 1818, describes all these very popular folds. Jane Austen made her brother's cravats, as did Catherine in *'Northanger Abbey'*, which was written in 1798–99 but not published until 1818. The cravat was introduced by Croatian Mercenaries in the service of the French during the 30-years war, (1618–1648). These picturesque scarves, distinctly knotted by the Croat military, were copied by the French and German Officers and became known as the cravat. The word 'cravat' is derived from a corrupt French pronunciation of Serbo Croat 'Khrvat'.

Due to the high rate of mortality during the late 1700s many cravat pins were made specifically to represent mourning, and their finials (heads) often bore miniature paintings using sepia on ivory or vellum. These mass-produced paintings were assembled from a standard set of designs using weeping willows shading a grave stone or urn, with an angel or classically dressed figure standing by in deep reverence, often holding a bow with a broken string and a quiver without any arrows. The designs were frequently made up from human hair with perhaps an urn, and the hair fashioned to represent Prince of Wales' feathers, with pearls and gold as part of the funereal theme.

The fashion of setting hair jewellery was well established by 1780 and was popular with many levels of society. Black tourmaline and melanite are also found in cravat pins of this period along with jet and black enamel. Pin heads were made in the form of serpents with their tails in their mouths to represent eternity. The butterfly as an emblem of the departed soul was also evident at this time, though more popular later, in the 1840s.

Louis-Sébastien Mercier (1740-1814), a French dramatist and writer, wrote between 1781 and 1784

'*Le Tableau de Paris*', a series of sketches of Parisian life seen via the inhabitants, places, institutions and, in particular, the sartorial fashion of the young men. Of great interest is the mention of a gold pin shaped like a butterfly. The decoration on the butterfly cravat pin is in bright cut engraving made possible by the use of new hardened and tempered steel engraving tools invented by Benjamin Huntsman around 1740 in Sheffield. This steel was capable of taking a very sharp cutting edge, but its use would have spread only slowly around the country because of trade practices, transport and travel conditions.

The cravat pin was the natural development of early ornamental dress pins. These early cravat pins were usually some 50mm in length with four or five zigzags in the overall length in order to hold the pin in place. By the turn of the 18th Century these were usually made of silver or gold with coloured stones set in the head of the pin. A variety of stones were used: e.g. paste, garnet, rock crystal, citrine, amethyst, topaz, black tourmaline and onyx. Moss agate was another popular ornamental stone because there appeared to be fossilised plant material in the stone. These inclusions are dendritic forms of iron and manganese oxide and appear in many different forms.

Moss agate was considered to be good for the sight and was held in high regard for its medicinal properties. Consequently, it was often used by physicians as a suitable material from which to make a pestle and mortar for the preparation of curative ingredients. A similar agate called '*Mocha stone*' also has inclusions of tree or fern-like structures and was originally obtained from Mocha in Arabia.

In England the use of paste or clear glass jewellery was also popular. This clear glass was probably based on the invention by George Ravenscroft (1618–1681) seeking to produce a material that simulated rock crystal. This material, known as 'glass of lead', had a very high percentage of lead in its composition. Indeed, in some of his early experiments his wine glasses contained so much lead that they were nearly black and water soluble! Ravenscroft set up his glasshouse in the Savoy in July 1673 and obtained his first patent about a year later. This invention may well have inspired the work of George-Frédéric Strass (1701–1773), who was born at Wolfsheim, near Strasburg, where he learned to make jewellery. He moved to Paris in 1724 and perfected a new technique for making imitation gemstones from lead glass. Between 1730 and 1734 Strass became famous for his paste jewellery and he died in 1773 a very wealthy man.

Paste was made in a variety of colours to simulate most popular gemstones. Lining the cavity into which the stone was set with a thin piece of highly polished metal or foil would greatly enhance the stone's appearance; also the colour of some stones was improved by painting the back of them with a coloured varnish. These backings acted as a reflector and made stones seem more brilliant in appearance, particularly as most domestic illumination was from candles set at a low level.

Fine paste became very popular in Paris between 1730 and 1740 and the trend was followed in London. Paste which was similar to the gemstone opal was set in jewellery between 1780 and 1820 in both England and France. This opaline paste (glass) was often used in cravat pins, usually in the late Victorian period, and it can be very convincing – caveat emptor!

Jewellery of this period was often representational, and the sequence of stones set out in a cravat pin or brooch was frequently used to convey an obvious, or hidden, personal message by using the first letter of each gem stone.

This was known as a rebus, riddle or acrostic.
The use of gemstones in this way is frequently found in Georgian and Victorian jewellery.

The following were very popular:-

REGARD	Ruby, Emerald, Garnet, Amethyst, Ruby and Diamond
AEI	Amity, Eternity and Infinity, (usually displayed as capital letters) meaning always or forever.
LOVE	Lapis lazuli, Opal, Vermeil (ancient name for hessonite garnet) and Emerald.

Garnets were thought to confer constancy, fidelity and cheerfulness, while the pearl was credited with the power of preserving purity.

Most of the best 18th Century paste was mounted in silver, with gold, for its greater strength, being used for the long pin. The stone was held in a 'cut down setting', which involved bringing the metal around the edge of the stone to provide an airtight seal thus protecting the foil backing on the stone from moisture, as well as ensuring that the stone was firmly set.

Most 18th Century clear paste shows a black dot at the culet or pointed end of the stone. It was standard practice for the setter to apply this painted black dot of pitch in an attempt to strengthen internal reflection. This treatment helped the paste to sparkle in the candlelight of the ballroom.

The black dot is clearly visible when viewing the stone from above and is strong evidence that the stone may be from the 18th Century.

The small pins used by men and women from the early 1700s evolved into elegant cravat pins that were larger and longer than the earlier ornamental dress pins. This was the period of European travel, known as The Grand Tour, which occurred before the Napoleonic Wars prevented travel in Europe.

The aim of this often-hazardous journey across Europe was to reach Italy and visit the great cities of Venice, Florence and Rome. Until the Napoleonic Wars the Grand Tour had been undertaken by the men of the aristocracy and might take anything from two to eight years.

During this time of reckless spending and wild living, styles of dress and the collecting of antiques and paintings had a considerable effect on these young men.

On their return to England, this group became known as fops or 'Macaronis'. They made fashionable the soft cravat style of the frilled collar and the fringed or laced cravat. A Club was formed 1764 to promote the idea that male dress should be simpler and plainer.

However, within a few years the movement was taken over by men with the exact opposite philosophy. Lace, super-fine materials, jewels, buckles, scent, cosmetics and ribbons became part of the male image and elegant pins would have been an important accessory. These pins were worn by men on their shirt frills and by women on their collars, stomachers and even in their hair during the 1770s and 1780s when hair was stiffly pomaded and powdered. False hair in fantastic styles was also worn and decorated.

By then, the term *'Macaroni'* had become an insult used to describe the absurd kind of fops in London Society.

Louis-Sébastian Mercier refers to young Frenchmen in Paris *'wearing a gold pin to show off the whiteness of the shirt'*. The young Englishmen returning from The Grand Tour brought European fashions into English Society. The Oxford English Dictionary refers to a 1780 Travellers' Guide that suggested a silver tie pin and three silver studs as necessities for the traveller. Dress pins had finials or heads made of coral, red jasper, glass or plain metal fashioned into elaborate geometric shapes, and these forms are found again in pins of the early Georgian Period.

In a small book, *'The New Bath Guide of 1766'* by Christopher Anstey, whose portrait may be seen at Beningbrough Hall, Yorkshire, there is a light humorous reference:

To cap like a bat
Which was once my cravat
Part gracefully plaited and pin'd is.

And later in the Guide:

If a toyshop I step in,
He presents a diamond pin;
Sweetest token I can wear.

During the 18th Century evenings were spent in candlelight, candles being placed on a table, and foiled paste jewellery would make a brilliant display, as previously mentioned. However, there was another form of jewellery that appeared at the end of the 18th Century which would rival the foiled paste jewellery in brilliance and this was known as cut steel. This metal was soft wrought iron made into tiny units which were faceted, polished and riveted onto a brass base-plate and made into all forms of jewellery.

The cut steel industry had its beginning in the small Oxfordshire village of Woodstock. This is some eight miles north of Oxford and near Blenheim Palace, the ancestral seat of the Dukes of Marlborough and the birthplace of Winston Churchill. Woodstock was a centre for very fine ironwork, possibly from Tudor times, but by 1780 it clearly had a reputation for a very high standard of craftsmanship, and its artefacts fetched correspondingly high prices.

It has been recorded that the best iron for jewellery came from old horseshoe nails. These iron nails were then annealed (softened by heating to a dull red) and drawn down into wire from which the small faceted studs were formed. These studs were shaped by stamping ready for riveting onto the back plate. This process is similar to the making of pins, which may be seen at Gloucester Folk Museum. It is likely that the studs were then polished by workers as part of a local cottage industry. The backing plate of brass, low grade silver alloy or tin, would have been cut to the desired shape and holes drilled in it to ensure a dense coverage of the faceted cut steel studs held to the backing plate by rivets.

Cut steel jewellery was made in Oxfordshire, London, Salisbury and in Birmingham, by Matthew Boulton at his Soho factory, and also in France. There appears to be no way of identifying cut steel from France unless it bears the word *'France'* on the backplate. As a general guide, 18th Century cut steel has as many as nineteen facets, while Victorian cut steel may have as few as five.

Towards the middle of the Victorian period cut steel jewellery had begun to fall out of fashion. It had become a very cheap type of jewellery made by mass production from very thin strips of material stamped out with simple faceted decoration.

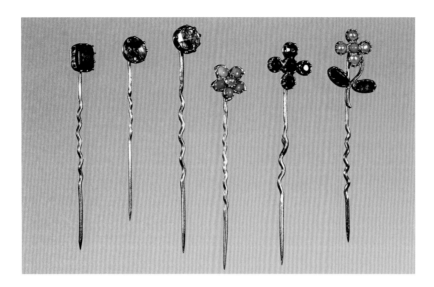

▲ FIG 13 Small ornamental pins with zigzag stems 1750-1800. The gemstones used include almandine garnets, pearls, black garnets (melanite), turquoise, quartz (rock crystal), citrines and pyrope garnets.

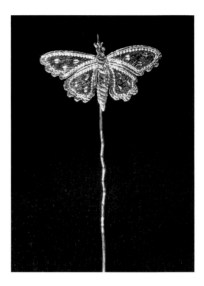

▲ FIG 14 Butterfly cravat pin c.1780. In an essay 'Le Tableau de Paris' Louis-Sébastien Mercier mentions 'a gold pin shaped like a butterfly'. The butterfly is a symbol for the soul.

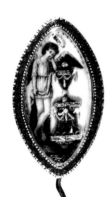

▲ FIG 16 Cravat pin 1782 - memorial pin for Joseph Nash, sepia painting on ivory showing St. Michael standing by an urn made of hair, decorated with gold strips and seed pearls. It has a blue enamel surround with a rock crystal cover.

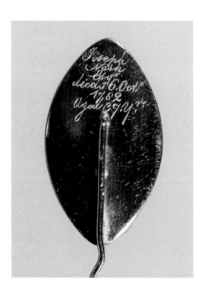

▲ FIG 17 Back of memorial pin 1782, engraved with '*Joseph Nash Esq died 16 October 1782 Aged 37 Years*'. The painted ivory plaque is held firmly against the rock crystal cover by a small tuft of sheep's wool placed behind the plaque acting as a natural spring.

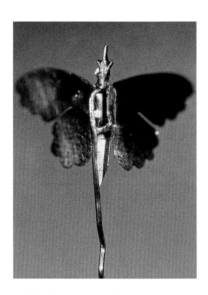

▲ FIG 15 Enlargement of the back showing method of attachment.

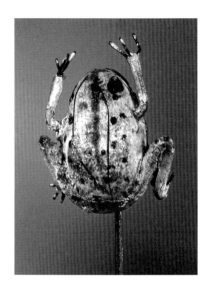

▲ **FIG 18** A Georgian cravat pin in the form of a frog made from papier maché (shreds of paper mixed with glue and moulded into shape) then painted with watercolour.

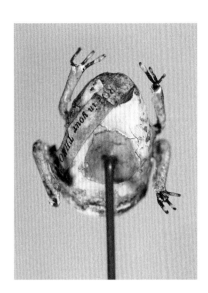

▲ **FIG 18B** The pin is iron and on the underside of the frog is a paper label: *'Frog in your Throat'*.

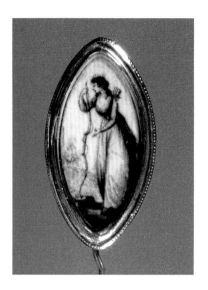

▲ **FIG 19** Memorial pin c.1780 - more usual style of memorial pin showing a woman standing with a bow with a broken string. A tuft of sheep's wool acts as a spring to hold the ivory memorial plaque in place.

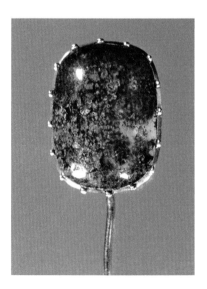

▲ **FIG 20** Cravat pin of moss agate which was a very popular Georgian ornamental stone; thought to be fossilised moss but is actually chalcedony with dendritic inclusions of manganese and iron oxides.

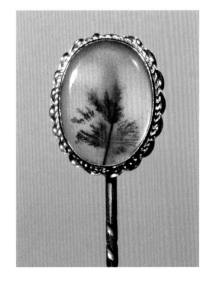

▲ **FIG 21** Tie pin c.1880 of a similar agate called Mocha stone.

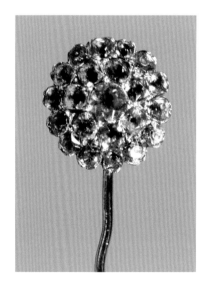

▲ **FIG 22** Cravat pin in paste (clear glass) to simulate diamond, showing the painted black dot applied to the culet (pointed end) to intensify the weak internal reflection in candlelight.

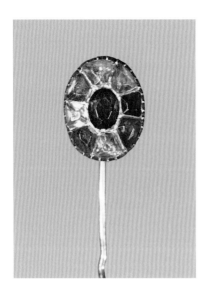

▲ FIG 23 Cravat pin with coloured paste stones. The sequence of stones may be a hidden personal message and only understood by the two persons involved.

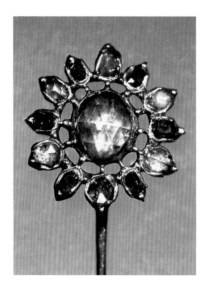

▲ FIG 25 Cravat pin with a 5mm diameter rose-cut diamond surrounded by six rubies and six diamonds c.1820. The diamonds may be from Golconda in India, as diamonds in this thin, flat, rough form were used because the mines were almost worked out and producing very few sizeable gems.

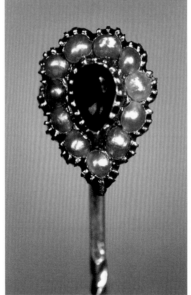

▲ FIG 27 Two cravat pins, each in the form of a mace, which was a favourite Georgian decoration, with engraved scenes.

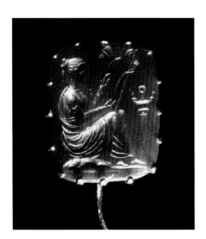

▲ FIG 26 This carved carnelian intaglio pin of Athena at her loom, shows a butterfly, which was the symbol for the soul and an oil lamp on a stand as the lamp of love. A moth fluttering around a burning candle might suggest the danger of falling in love.

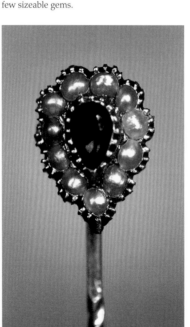

◄ FIG 24 Cravat pin in the form of a heart with a central faceted almandine garnet surrounded by eleven seed pearls. Almandine garnets have a violet hue in their basic colour of red and take their name from Alabanda in Asia Minor where, according to Pliny the Elder, this type of stone was cut and polished.

▲ **FIG 28** Cravat pin in the form of a mace with a chain and small pin with a turquoise stone as a token of affection.

▲ **FIG 29** Cravat pins in cut steel - 1750 to 1850. These are three examples c.1800, when the use of candles for lighting produced horizontal light, rather than overhead light, and this made the cut steel jewellery sparkle.

◀ FIG 30 Cravat pin in cut steel of a single insect.

CHAPTER 3

Progression of Cravat Pins to Tiepins during late 18th Century

John Field silhouette 1815 – Black African cameo c 1785 – diamonds – Golconda – Brazil – Wedgwood – Lord Nelson Tassie – The Elgin Marbles – ivory carvings – Berlin Ironwork – Pinchbeck.

During this period cravat pins were usually understated and were worn to display the owner's interests, perhaps as a traveller, scholar or successful businessman. An example of this may be seen in the illustrated gold Georgian cravat pin made c.1785 (just prior to the Napoleonic Wars) which shows the head of a woman of African descent, wearing a silver collar set with four rose cut diamonds and a gold earring. This cravat pin raises many interesting possibilities of interpretation. The author's research has revealed that it almost certainly belonged to a family who had lived in Liverpool, and who had connections with the slave trade in the 1700s. The style suggests a man proud of his plantations in the West Indies, perhaps of one particular female worker, and at ease with his business colleagues - by displaying his wealth and business interests. The entire cravat pin shows extreme wear, as if by having been worn almost continuously over a long period. It has extensive repairs with soft solder, and the back of the jewel is badly dented. The long pin itself has begun to crack because bending and twisting have caused work-hardening of the gold. It can only be a matter of speculation as to any later significance of this pin after the abolition of slavery in 1807. Later in the century, such a cravat pin may have indicated a strong inclination towards the work of William Wilberforce (1759–1833) and Thomas Clarkson (1760–1846),

who brought about the banning of the British slave trade in 1807. Alternatively, its wearer may have used the pin as a symbol of his own belief in himself as a good slave master, or indeed it may have been put away after 1807 and never worn again. The final Act that emancipated the British slaves was passed in 1833, three days after the death of William Wilberforce.

The expense of the Napoleonic Wars between 1793 and 1815 had little effect on those more wealthy in Britain, although it did become difficult to obtain French designs from Paris. However, for the poor, the cost of food caused widespread poverty. Income tax was introduced, and also in 1797, the country came off the gold standard. In spite of the difficult economic situation there was an overall increase in national wealth, but it was unevenly distributed. However, at this time the wealthy still commissioned jewellery and bought diamonds from India, where they had been mined since ancient times. But in the early 1800s diamonds from South America became popular, where they had been originally discovered in 1725, although it was not until 1867 that diamonds from South Africa appeared.

By late Georgian and early Regency periods, diamonds and coloured stones were now often set in unbacked collets or settings to give the effect of more

transparency by allowing light to enter both from behind and in front of the stone. It was usual to set diamonds in silver, and coloured stones in gold. In 'Roderick Random' by Tobias Smollett, published in 1748, there is a description of Captain Whiffle's dress uniform mentioning 'a brooch set with garnets'.

Coral, mosaics and pietra dura are recorded already in the early 1800s, and their popularity increased after the fall of Napoleon, when travel in Europe became easier with better roads, inns and transport.

Also, at this time the dangerous process called fire-gilding, which used an amalgam of mercury and gold, was introduced in some jewellery making, but rarely on cravat pins.

The amalgam was painted onto the object to be gilded and the mercury burnt off. This left a brilliant coating of gold on the gilded article, but the mercury vapour contaminated the atmosphere, causing severe brain damage to the workers.

However, for the less wealthy, inexpensive trinkets were manufactured from a new alloy called 'Pinchbeck'. This metal, used to imitate gold, was invented in London about 1720 by a London watchmaker, Christopher Pinchbeck (1670–1732).

It was so successful that the alloy became known as 'Pinchbeck'. It is an alloy of 83% to 88% copper and 12% to 17% zinc. Its use declined after 1854 when it was superseded by gilding metal (80% to 95%

◄ **FIG 44** Cravat pin showing the profile of Vice-Admiral Horatio Nelson, 1758-1805, in an oval black glass cameo inscribed on the termination of the right arm with the words 'Tassie F 1805' ©National Maritime Museum, Greenwich, London.

copper, 5% to 20% zinc) and rolled gold. Rolled gold was developed in 1817 and was prepared by bonding a thin sheet of gold onto a sheet of base metal, then rolling it into sheets, similar to the method of producing Sheffield Plate.

In 1854 9ct gold was introduced; this consisted of 37.5% gold alloyed with silver, copper and other metals, depending on the working characteristics required by the jeweller.

In 1798, the year of Nelson's victory in the Battle of the Nile, jewellery celebrating the English victory was seen in London. In the National Maritime Museum in London there is a mourning cravat pin with an oval black glass cameo, simulating onyx, depicting a portrait of Vice Admiral Lord Horatio Nelson (1758–1805). The portrait is made in white vitreous paste and is inscribed on the front of the cameo with the words 'Tassie F 1805'. Wedgwood cameos and Tassie pastes were worn in the early 1800s. The illustration of a Wedgwood cameo in two colours c.1800 was probably set in a tie pin some years later. James and William Tassie also made models for Josiah Wedgwood to use for casting jasper-ware medallions from 1769 to 1780. James Tassie (1735–1799) was a gem engraver and modeller, who produced, during the Classical Revival, a series of casts of antique gems, cameos and intaglios in coloured paste. The term 'paste' has come to be applied to all special forms of glass used to imitate gemstones.

The ingredients are mixed in the form of a wet paste that is cast into moulds. 'Tassie' medallions contain a high lead content, have a relatively low melting point and are easily cast. The medallions were made in both opaque and transparent forms. They were also made in sunken 'intaglio' form and in relief, as 'cameos'. After James Tassie died, his nephew William Tassie (1777–1860), continued to make medallions, and in 1840 the firm passed to James Wilson.

During the first 50 years of the 19th Century, an art form flourished in Germany that was practically forgotten by the time of The Great Exhibition of 1851 in London. This was the Prussian fine-art casting of statues, jewellery, medallions and household articles in cast iron. The centre of the cast iron industry moved in 1804 from Gleiwitz to Berlin. There it became a renowned centre of excellence under the patronage of King Frederick William III (1770–1840) and was called The Royal Prussian Foundry. The Foundry had barely been open for two years when, in 1806, Napoleon captured Berlin, and many of the original patterns were taken to Paris where cast iron jewellery in the neo-Classical style was produced for some time.

During the War of Liberation against Napoleon from 1813-1815 the Prussian government needed money for munitions and, in a period of intense national enthusiasm, asked the nation to give up their gold and jewellery to support the national cause. In return, the contributors were given items of jewellery made of cast iron. The pieces bore the inscription 'Eingetauscht zum Wohle des Vaterlandes' meaning 'exchanged for the welfare of the Fatherland' and also 'Gold gab ich für Eisen' meaning 'I gave gold for iron'. The majority of cast iron jewellery was made between 1813 and 1815. In 1814 over 41,000 items of jewellery were made.

In 1815 with the advent of peace in Europe, the production of German decorative items in cast iron expanded rapidly. Many of the items were of very high quality and expensive enough to hold their own against those made of noble metals. From 1815 the neo-classical influence gave way to more naturalistic designs in the form of flowers, leaves, etc. After 1830, neo-Gothic designs became more popular, with shapes which were usually associated with high church architecture, although some jewellery combined both Gothic and naturalistic influences.

So-called Berlin ironwork jewellery was also produced at other centres in Europe, notably France and England, but it is very difficult to state with certainty where a piece was made unless it bears a maker's mark. The best makers were Dumas of Paris and Johann Conrad Geiss of Berlin.

The manufacture of Berlin cast iron jewellery, because of its delicacy and precision, required highly skilled pattern makers and foundrymen. Each pattern was first carved in wax and then invested or covered in a refractory plaster, prior to being burnt out in a furnace (cire perdue), the ancient lost wax process. The mould made from this pattern was then cast in bronze to give a permanent working pattern. Many of these patterns were carved by very skilled jewellers working in Berlin.

To produce a mould for casting the iron jewellery, a mixture of very fine sand, brick dust, or similar refractory material, was milled with clay and the requisite amount of water added to give a strong bond. This mixture was then rammed around the bronze pattern in a split flask (container), thus giving an impression of the front and back of the pattern. The fine refractory material was confined to the area surrounding the pattern to ensure a perfect finish,

the rest of the flask being filled up with a back-up sand mixture.

The two halves of the flask containing the sand mould were then separated to reveal the impressions of the back and front of the design. After removal of the pattern and the cutting of fine gas venting channels and sprues (small inlets for the liquid iron) the two halves of the mould were thoroughly dried in an oven to remove all moisture. This was most important as the material used for the formation of the mould had low permeability and would not easily allow gas or steam to escape. Moisture remaining in the mould could result in an explosion and the destruction of the mould when the molten cast iron was poured.

Before closing the mould for casting, the impression was smoked with a wax/resin torch to give a fine carbonaceous surface resistant to the molten cast iron and to ensure a fine surface for casting.

The fluidity of the molten iron was of utmost importance and cast iron of approximate composition 3.2% carbon, 2.3% silicon, 0.7% manganese and 0.7 – 1% phosphorus (which has good fluidity) was used together with a high casting temperature of 1450°C. It is likely that crucible melting where a very high metal temperature could be attained was used for the most delicate castings. After fettling (hand-finishing), the jewellery casting was given a coat of matt black lacquer as a protection.

It is known that some cast iron jewellery was produced during this period by a die-casting process using heated iron dies, whose surfaces were coated with a layer of soot to act as a release agent and to protect the surface of the die.

The final blow to the Fine-Art Casting in Berlin came on 18 March 1848, when a drunken mob set fire to the foundry buildings and then tore down the blackened ruins of the workshop. By the time of The Great Exhibition there were many other forms of jewellery, and cast iron did not harmonise so well with the more colourful and elaborate dresses then in fashion. Its use went into decline, but it did retain some popularity as mourning jewellery.

Because Berlin ironwork is fragile, it is rare, very collectable and therefore expensive. The cravat pin in the form of a fly is a rare example of Berlin ironwork and was presented to Dr. Henton Morrogh, FRS, Director of the British Cast Iron Research Association in the late 1930s, while on a visit to Dusseldorf, Germany. The cravat pin was kindly donated to the author of this history, by Mrs Olive Morrogh, for his research on tie pins. This cravat pin is made of cast iron and known as the 'Sayner Mücke' - a life size fly.

In 1830 a foundry was built near the Sayn Palace and became famous for its ornamental cast iron work. The Sayn Palace, situated near Koblenz, now houses the Rhenish Museum of Ornamental Cast Iron and is an important centre for examples of Berlin Ironwork. *(Research by author and A D Morgan on Berlin Ironwork - see bibliography)*

Ivory was carved throughout Europe, where the most important centre was Erbach-in-Odenwald, near Frankfurt. This industry was established there in 1781, and specialised in carving deer and horses, the best of which were carved by Ernst and Eduard Kelvier. Other craftsmen were Hartman, who carved delicate roses and Willman, who carved hands and roses. At this time images of hands were popular as love tokens.

When the Elgin Marbles were first exhibited in June 1807, it became the event of the Season. London society women adopted Greek-style dress, and men wore cravat pins made in a similar style to the marble horse with the broken ear. In 1809, Lord Byron denounced Lord Elgin as *'a despoiler and plunderer'*. In 1816, a Parliamentary Select Committee examined the right of Lord Elgin to the ownership of the Marbles and, later that year, the Marbles were exhibited in the British Museum.

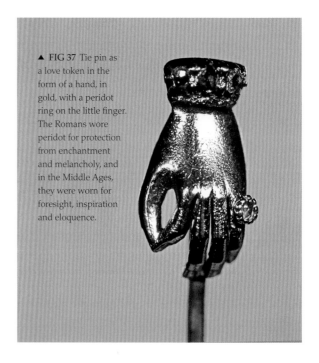

▲ **FIG 37** Tie pin as a love token in the form of a hand, in gold, with a peridot ring on the little finger. The Romans wore peridot for protection from enchantment and melancholy, and in the Middle Ages, they were worn for foresight, inspiration and eloquence.

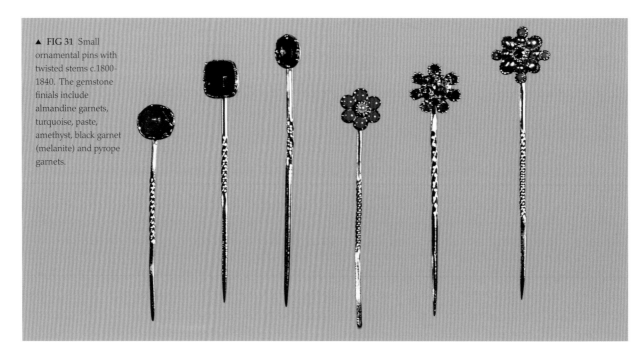

▲ **FIG 31** Small ornamental pins with twisted stems c.1800-1840. The gemstone finials include almandine garnets, turquoise, paste, amethyst, black garnet (melanite) and pyrope garnets.

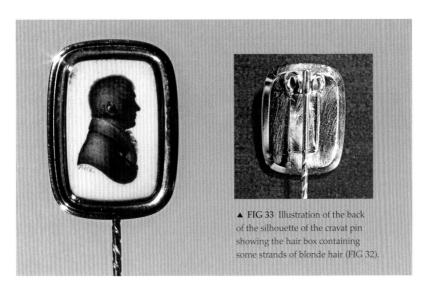

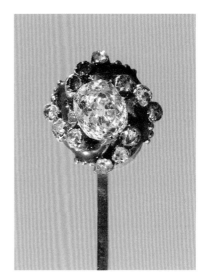

▲ FIG 33 Illustration of the back of the silhouette of the cravat pin showing the hair box containing some strands of blonde hair (FIG 32).

▲ FIG 32 Cravat pin in gold with hair box at the rear of the pin c.1815. On the front of the pin is the silhouette of a gentleman: profile to the right, wearing a coat and tied cravat – his hair shaded with bronze paint. Silhouette is signed by John Field (1772–1848). Many cravat pins have a concealed compartment, called a *'hair box'*, at the back of the pin, for hair or other tiny mementoes.

▲ FIG 35 Cravat pin, c.1830, with a cushion-cut diamond and blue enamel decoration. The pin has a square stem with a simple twist.

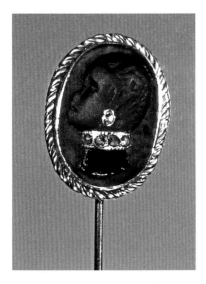

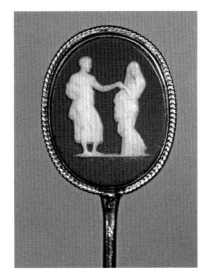

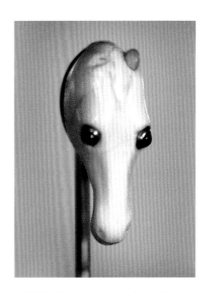

▲ FIG 34 Georgian cravat pin in gold c.1775, set with a basalt cameo and an obsidian repair to the neck of the female head of Black African ancestry, wearing a silver collar set with rose cut diamonds, on an agate background.

▲ FIG 36 Cravat pin - Josiah Wedgwood cameo, in traditional blue and white jasper ware, of two classical figures.

▲ FIG 38 Cravat pin showing the head of a horse with garnet eyes, carved in ivory. The horse has a broken ear, similar in design to the one displayed in the Elgin Marbles, known as the Horse of Selene.

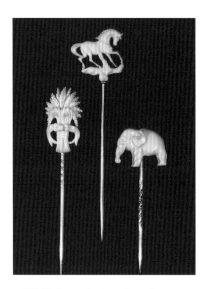

▲ FIG 39 Cravat pin - ivory horse German c.1840 and two other ivory carvings, possibly from Dieppe and the Far East. Ivory carvers also exhibited at the Great Exhibition of 1851 in Hyde Park, London.

FIG 40 Cravat pin - Tassie intaglio in black glass by James Tassie (1735-1799), who made cameos and intaglios from paste. After his death, his nephew, William Tassie (1777-1860), continued to make medallions. Catherine the Great of Russia had a large collection of Tassie cameos.

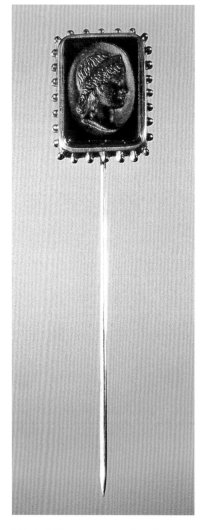

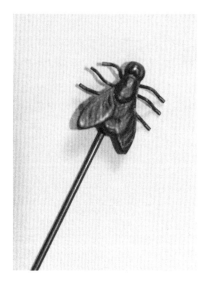

▲ FIG 41 Cravat pin made from Berlin ironwork and showing a fly c.1830. The fly is a symbol for humility and unity.

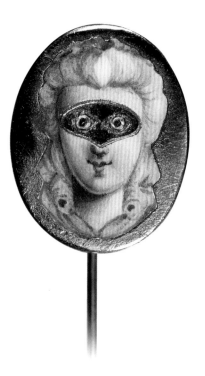

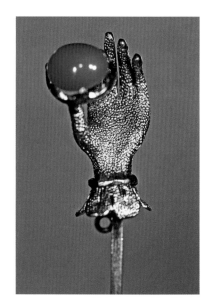

◀ FIG 42 Gold tie pin c.1825 made in the style of a late 17th Century masked woman in champlevé enamel. The eyes are rose cut diamonds and the pin evokes the intrigue of the masked ball.

▲ FIG 43 Tie pin made of 'Pinchbeck', an early imitation of gold, in the form of a textured hand holding a turquoise stone, circa 1820. Hands are a symbol of commitment and the turquoise, of love.

CHAPTER 4

Travels in Europe and the increasing popularity of male jewellery

Napoleonic Wars 1793-1815 – Napoleon cameo – Nelson Tassie – Continental holidays in the Grand Manner – micro-mosaics – pietra dura – lava jewellery – Beau Brummell – hardstone intaglio and cameo carvings – seed pearls – Alfred, Count d'Orsay 1839 & 1845 – pearls – talisman – portrait 1836 Bodellwyddn group – Continental holidays with Thomas Cook – love tokens.

English tourists flooded back to Paris in 1814 and again after the abdication of Napoleon. The depression that came after the Napoleonic Wars persisted for some twenty years and the poverty of the agricultural workers led to their flight from the land to industrial towns. England had been at war with France from 1793 until 1815 and this brought to a close the great period of the Grand Tour which had been largely created by the aristocracy and upper classes.

After the final defeat of Napoleon at Waterloo in 1815 it was again possible to travel with some safety in Europe. Now, with the increase of wealth in the middle classes, shorter holidays in the style of the Grand Tour took on a renewed vigour and were supported by the now wealthy middle class, and less so by the aristocracy. In 1841 Thomas Cook organised his first excursion to Loughborough and in 1863 his first tour to Switzerland. The spread of better-made roads, hotels, restaurants, and, later in the century, railways, made mass-tourism possible. The Victorian earnestness and desire for self-improvement now took the place of the Georgian casual attitude towards culture and art. Tourists returning from these Grand Tour style holidays brought souvenirs home as presents, the most popular items were made of pietra dura, micro-mosaics and coral.

Fine Roman micro-mosaics set in dark blue glass or black Belgian slate were used as ornamentation on furniture, as pictures and in jewellery. The finest of these showed a smooth surface where the joins were hardly visible to the unaided eye. Such pictures of views in and around Rome could have over 1,400 small tesserae to the square inch. As more tourists flocked to Italy later in the century, most of these micro-mosaics were almost mass-produced as souvenirs for tourists, and, although attractive, had become quite crude.

In Florence, plaques were made of hard ornamental stones and coloured marbles, fitted together rather like a jigsaw puzzle, mounted in black marble and called '*pietra dura*'. The subjects were mostly leaves, fruit, flowers and birds and were poetically termed '*stone painting*'. These designs showed an artistic and sensitive use of natural materials and may be seen at the Museo Dell'Opificio Delle Pietre Dure in Florence, and in the Gilbert Collection at the Victoria and Albert Museum in London.

In the mid-19th Century, similar inlaid marble jewellery was made in England with marbles from Hopton (Derbyshire), Torquay and Wales.

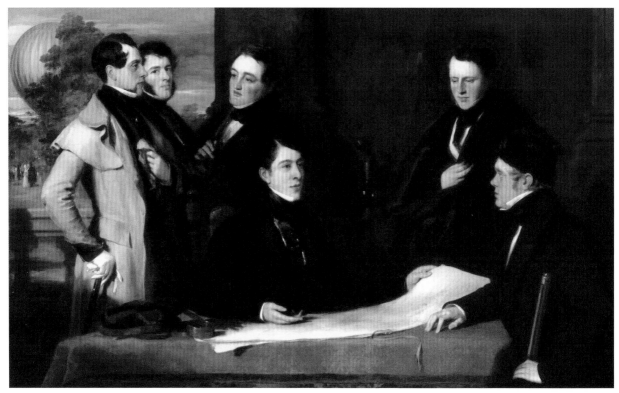

▲ **FIG 54** *'A Consultation prior to the Aerial Voyage to Weilburgh (1836 –1838)'* - Artist John Hollings (1798-1855) ©National Portrait Gallery. The picture shows a group of young men wearing a variety of tie pins.

This was a period of excellence for both English and Italian craftsmen, with some similarity of designs. English craftsmen often used a paste of powdered marble mixed with resin to fill small spaces, stems of flowers and similar parts of the design. This may be detected using a magnifying glass or a jeweller's loupe, and on examination, the paste shows up as a speckled, powdery surface.

Many different ornamental materials were now being imported; for example, seed pearls from India, and jewellery made from these very small seed pearls began to appear around 1810. These pearls were drilled and threaded onto horsehair or silk. This form of jewellery was delicate but also very fragile and is now rarely found in perfect condition. At this time cravat pins were also made with seed pearls, but similarly these are now seldom found in perfect condition. The jewellery trades began to recover in the 1830s, making way for the successful Victorian era, and England became progressively more prosperous with a new class of wealthy industrialists.

It was George Bryan Brummell *(1776–1840)*, better known as Beau Brummell, who began to influence society with his good taste, neatness and cleanliness. In the first biography of Beau Brummell by *'Captain Jesse'*, an anonymous friend, who had known him at the height of his fame in London, and not in his years of exile, recollected that: *'He was not a fop, as many think*

he was: he was better dressed than any man of his day. And we should all have dressed like him if we could have accomplished it. The tie of his neck cloth and the polished surface of the boot-top were then great objects of attention and no one rivalled him in those attributes'.

The cravats of the early to mid-18th Century were held in place by a gold cravat brooch often containing gems or paste, surrounded by pearls. Later in the 18th Century, brocade and silk waistcoats, some with gold and silver thread, were fashionable. By this time, the new soft cravat had made its appearance and the art of tying the cravat with an interesting knot had become a matter of great importance. Valets notably skilled in the art would charge one guinea a time for tying a cravat in a particular style. Brummell moved to 4 Chesterfield Street, London in 1799, and some of his friends would watch him tying his neck cloth. Not all Brummell's morning guests had the honour of watching him, but would wait downstairs and ask his valet, Robinson, as he descended the stairs, about the *"quantity of tumbled neck cloths under one arm?"* He would reply *"Oh these, sir, these are our failures"*. It is important to remember that these cravats, so carefully tied, and perhaps at some expense, could easily become loose and give rise to considerable embarrassment. To secure it in a vertical position, a cravat pin was needed to hold it firmly in place.

Beau Brummell fell out with the Prince of Wales in 1813, and in 1816, to escape his creditors, he left England for France, where he briefly held a Consular post, but was subsequently imprisoned for debt. Finally, destitute, he died of advanced syphilis in an asylum for the insane in Caen.

As 19th Century fashions evolved, the cravat changed; and by 1830, the scarf or shawl cravat had become fashionable. This cravat was so voluminous that a cravat pin was essential to hold it to the shirtfront, and this was caricatured in Punch. There is also a caricature of Count d'Orsay, a dandy of the time, wearing a shawl cravat, and this was printed in the Frasierian Magazine in 1834. In 1839, Count d'Orsay visited Jane Welsh Carlyle *(wife of Thomas Carlyle, the Scottish historian and essayist)* and she describes his visiting costume in some detail – *'sky blue satin cravat, yards of gold chain, white French gloves, light drab great coat lined with velvet, invisible inexpressibles,* (trousers) *skin coloured and fitting like a glove and two glorious breast pins attached by a chain'* (1839 Letters of Jane Welsh Carlyle).

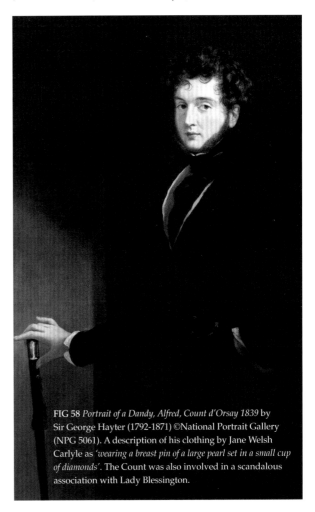

FIG 58 *Portrait of a Dandy, Alfred, Count d'Orsay 1839* by Sir George Hayter (1792-1871) ©National Portrait Gallery (NPG 5061). A description of his clothing by Jane Welsh Carlyle as *'wearing a breast pin of a large pearl set in a small cup of diamonds'*. The Count was also involved in a scandalous association with Lady Blessington.

Some five years later she describes Count d'Orsay again *'wearing a breast pin of a large pear-shaped pearl set in a little cup of diamonds'*.

Another very fashionable gentleman was Charles Dickens and there is a fine portrait of him in the National Portrait Gallery, NPG 1172, painted by the artist Daniel Maclise, dated 1806, showing Dickens wearing a double pin.

The change in shirt styles began in 1820 and gradually collars became lower. As the century progressed, they went up to the cheek bones and, as fashions changed, came down again! This lowering of the shirt collar in the mid-19th Century had a considerable effect on the style, width and size of men's neckwear: cravats and stocks became narrower and less voluminous, almost like ribbon, as seen in the Byron tie.

Towards the end of the century, the working man adopted the forerunner of the modern tie and favoured a small tie pin.

It is important to observe the gradual change in the form of the cravat pin into the tie pin and that materials used for neck wear and fashions would be so significant in the change. In broad principle the cravat pins of the late 1700s were small pins with zigzag stems and a jewelled finial.

In the early 1800s cravat pins began to evolve into pins with stems that were longer, thicker and had twists that almost resembled mechanical threads.

There is no exact date for the change from term *'cravat'* pins to *'tie'* pins, but the period from 1790 to about 1830 could be called 'a time of transition'. After 1830 the stem became longer and thicker and the twists fewer and were to be found in the middle section of the stem.

The twists helped to keep the pin in place in order to prevent the cravat or tie becoming untied or the pin from falling out.

Towards the end of the Victorian period a small barrel shaped, spring-loaded clutch was designed to be placed on the end of the pin to prevent it falling out and to avoid injury to the wearer! The use of this clutch frequently baffles the modern user until they realise that by lifting the upper part of the barrel shape and holding down the bulb-shaped lower part they can compress the spring and release the tie pin.

Many ornamental tie pins may still be found with straight stems that were made without twists in them from the early 1800s to the present time.

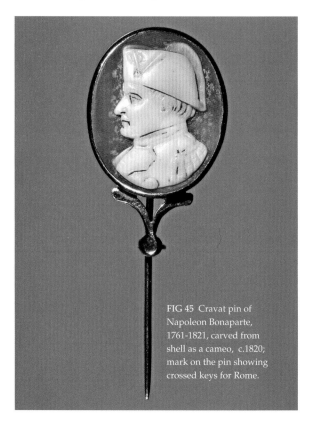

FIG 45 Cravat pin of Napoleon Bonaparte, 1761-1821, carved from shell as a cameo, c.1820; mark on the pin showing crossed keys for Rome.

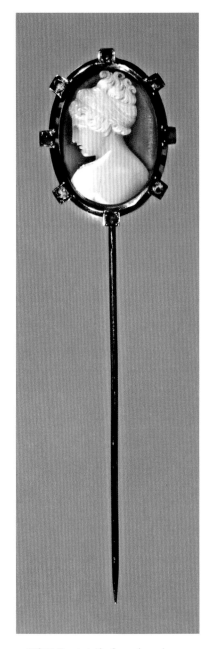

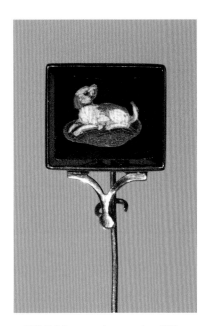

▲ **FIG 47** Micro-mosaic cravat pin, c.1825, of a small lap dog. A Grand Tour memento with a '*Rome*' mark on the pin.

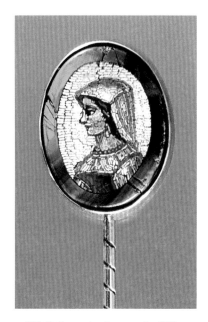

▲ **FIG 48** Cravat pin micro-mosaic c.1830, of a Roman Lady – Grand Tour memento with a 'Rome' mark on the pin - crossed keys.

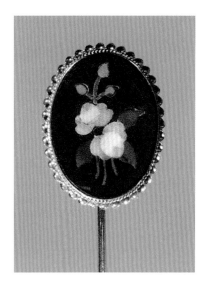

▲ **FIG 46** Tie pin in the form of a sardonyx cameo by neo-classical sculptor Antonio Amastini 1754-1816. Cameos in this form are sometimes referred to as '*hardstone*' cameos.

▲ **FIG 49** Cravat pin, c.1860, micro-mosaic bee, Grand Tour memento with a '*Rome*' mark. The bee symbolises the pleasure of sweet honey and the pain of being stung – the pleasure and pain of love.

▲ **FIG 50** Cravat pin - *pietra dura* from Florence c.1870. Florentine hardstones or *pietra dura* were made from carefully cut and polished stones. These were assembled into small pieces of jewellery, tables, boxes and pictures.

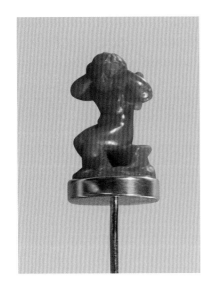

▲ **FIG 51** Coral sculpture cravat pin in the form of an Amorini. The coral was probably carved at Torre del Greco, south of Naples c.1840. In Roman times, coral was believed to prevent ailments in children.

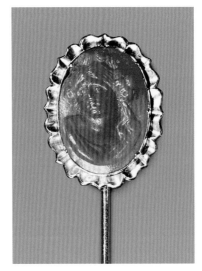

▲ **FIG 52** Coral cameo of a woman's head and shoulders as a cravat pin. Coral was worn to avert the evil eye and for its medicinal qualities.

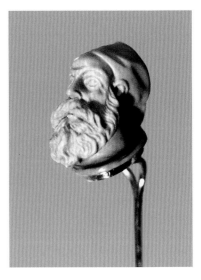

▲ **FIG 53** Cravat pin showing a Philosopher's head carved from lava *(an impure limestone found as pebbles around Vesuvius)* c.1860.

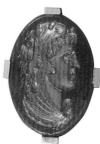

FIG 55 Cravat pin in the form of a neo-classical intaglio carving of Hercules with the skin of the Nemean Lion over his head, which made him invincible. The material is cornelian, which takes a very high polish and, for its hardness, is also used for carved seals. As a talisman, it is said to protect the wearer from the evil eye and ill health, and to give eloquence and courage, c.1860.

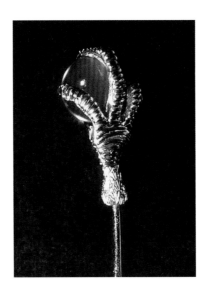

▲ **FIG 56** An eagle's claw clasping a Mexican fire opal set in a cravat pin c.1860. The eagle is the talisman for dignity, perception and good fortune.

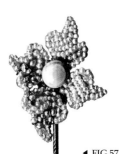

◀ **FIG 57** Cravat pin, c.1825, of a seed pearl flower. At this time, complete sets of jewellery were made from hundreds of minute drilled seed pearls, 0.5 mm or less in diameter, and strung together with lengths of horsehair or silk. These delicate items of jewellery were very fragile; consequently few have survived in perfect condition. The centre pearl has a blue sheen and may be a freshwater variety.

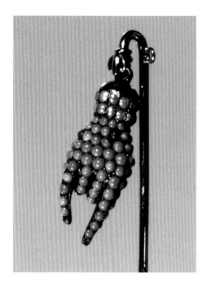

▲ **FIG 59** Tie pins were made and worn as a defence against superstitious omens, for example, a hand, with turquoise stones held in a particular way was thought to ward off the evil eye from one's loved one.

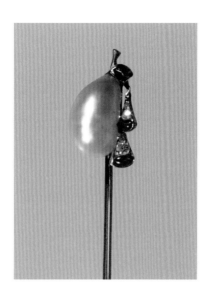

▲ **FIG 60** French tie pin, c.1860, made from a baroque pearl with rubies and diamonds - a very potent collection of love talismans - purity and passion forever.

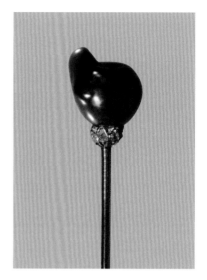

▲ **FIG 61** Tie pin, c.1850, black pearl from Persian Gulf showing a colour change to deep brown as the pearl has aged. This colour change is found in black pearls from the Persian Gulf. Pearls were often arranged with one white and one black to suggest the light and dark sides of passion. A white pearl signifies innocence, purity and perfection.

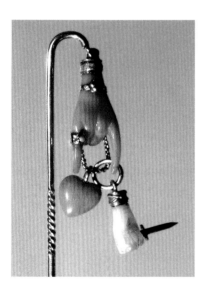

▲ **FIG 62** Tie pin with talismanic symbols of a hand and heart in coral with a smaller hand holding a dagger.

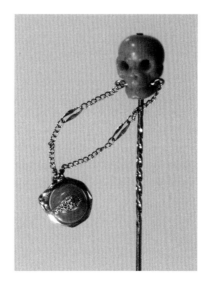

▲ **FIG 63** Tie pin c.1870 with a coral skull and a serpent coiled around a fruit, symbolising the fall of man in the Garden of Eden. *The Bible, Genesis, Chapter 2 verses 15, 16 & 17 and Chapter 3.*

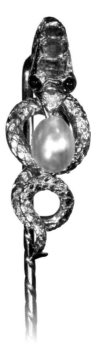

◀ **FIG 64** An 18ct gold tie pin of a love token in the form of a serpent, with three fine emeralds set in the head (hope), two ruby eyes (passion) and a pearl (purity) suspended from the mouth, c.1845. The emerald was also considered very beneficial to the eyes and it is recorded that Nero used an emerald eyeglass, but it is more likely that he used the eyeglass to shade his eyes from the glare of the arena. *Pliny the Elder, Natural History book 37, section 17, footnote b, translated by D.E.Eichholz.*

CHAPTER 5

The Great Exhibition 1851 and the death of Prince Albert in 1861

Daguerreotype – coral – shell cameos – hardstone cameos – humming bird feathers – Tara brooch pin – Scottish & Irish – Bohemian garnets – sentimental and love tokens – piqué and tortoise shell – language of flowers – death of Prince Albert 1861 – memorial pins – insects – Austrian cold-painted bronze - portrait of Henry Fawcett wearing a love knot pin.

In 1843 Prince Albert became President of The Royal Society of Arts and set in motion arrangements for The Great Exhibition in 1851, whose original title was *The Great Exhibition of the Works of Industry of all Nations.*

Male jewellery had become popular but was formal and discreet, in keeping with the new mood of Victorian conformity. Nevertheless, many cravat and tie pins were exhibited. The Philip Brothers offered single gold pins with gold heads of falcons, cockerels and game birds, along with an enamelled cap with a whip, spurs and a fox brush. In contrast, one with a bust of William Shakespeare was also exhibited.

◄ **FIG 99** Memorial cameo tie pin of Prince Albert in black and white onyx c.1861.

In keeping with the grand exhibition title, Bohemian garnets were exhibited by the Prince von Lobkowitz, who owned mines at Bilin near Prague, and had been a patron of Beethoven. Cameos, coral and pietra dura were all displayed and some micro-mosaic jewellery. Ivory and tortoiseshell were also popular and turquoise was fashionable as a sentimental love token appearing in many tie pins. The use of platinum was exhibited but made little impact, but some Berlin ironwork was on view and this was purchased for the new Museum of Manufacturers, later to be the Victoria and Albert Museum.

Large diamonds were very spectacular and the Koh-i-Noor diamond was lent to the Exhibition by Queen Victoria. She was much taken with the work of the French jewellers who exhibited at The Great Exhibition, and whose stands she visited on a number of occasions. Overall, The Great Exhibition was a personal triumph for Prince Albert, and Queen Victoria was justly proud of his achievement.

Jewellery motifs seen at The Great Exhibition included shells, flowers and fauna, serpents, butterflies, insects and many more. During this time there was also a growing interest in archaeological jewellery.

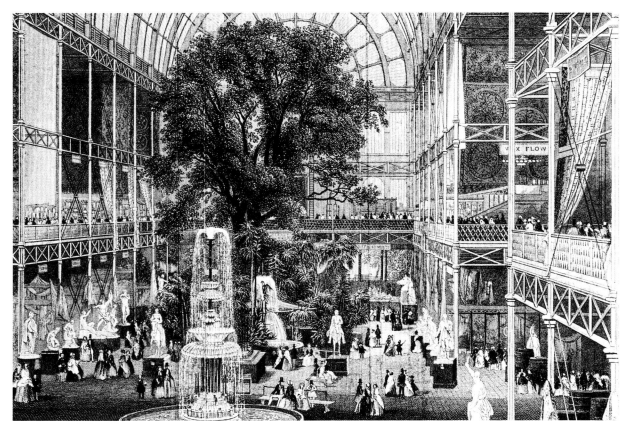

▲ Daguerreotype showing the Great Exhibition 1851 Hyde Park, London. Transept of the Exhibition looking north. Engraved by W. Lacey from a Daguerreotype by Mayall. Prince Albert was Chairman of the Exhibition Committee. The 1851 Catalogue is available in 3 volumes.

However, one of its greatest exponents, Castellani, did not take part in The Great Exhibition, although he was already held in high regard for his archaeological designs.

Copied in time for the Great Exhibition in 1851 the gold 'Tara' brooch is an early 8th Century gilt bronze Irish pin brooch found by chance on 24th August 1850 in the neighbourhood of Drogheda, possibly on the beach at Bettystown, near Laytown, County Meath. The poor woman who found it claimed that her children had picked it up on the seashore. The brooch is named after the Hill of Tara, County Meath, which is the seat of the mythological High Kings of Ireland.

The brooch was ultimately purchased by Waterhouse & Co of Dublin, but it seems that Waterhouse did not attempt a faithful full-scale reproduction of the original. This was left to Joseph Johnson of Dublin who provided a life-size copy for the Victoria & Albert Museum. The original brooch is now on display in the National Museum of Ireland, Dublin. It would seem that the tie pin illustrated is a simple casting, representing the original brooch.

A full account is to be found in *'The Finding of the Tara Brooch'* by Niamh Whitfield.

During the reign of Queen Victoria there was a very strict code of mourning that had to be observed following a death in the family. When Prince Albert died in December 1861, Britain was plunged into mourning and the Queen remained in mourning for most of her life thereafter. Black was worn as a mark of respect and the wearing of jewellery was very restricted. Mourning jewellery was made from black enamel, onyx, piqué tortoise shell (the shell of the Hawksbill turtle), niello, bog oak, jet, black glass and some early plastics.

Black glass jewellery was popularly known as 'French jet' and is sometimes found made into tie pins. It is not completely opaque and, when held up to the light, shows a purplish translucency at the edges.

Jet is basically a fossilised black variety of brown coal or lignite, which sank to the seabed and became embedded in a rock formed from fine mud. It is harder than coal and capable of taking a high polish. The finest jet is found at Whitby and along that part of the Yorkshire coast. In the Victorian period it was a major industry and, at its height in the early 1870s, employed between 1,200 and 1,500 men, women and children. It is advisable to examine items with great care as some imitations in modern plastics can be very convincing.

Bog Oak is a wood, mostly oak, that has been preserved in peat marshes for many hundreds of years.

Niello is a method of inlay, similar to champlevé enamelling, using an alloy of copper, silver, sulphur and lead.

Piqué tie pins were popular as a restrained item of jewellery. The tortoise shell can be moulded by the use of heat, and in piqué decoration small pieces of gold and silver are inlaid into the shell.

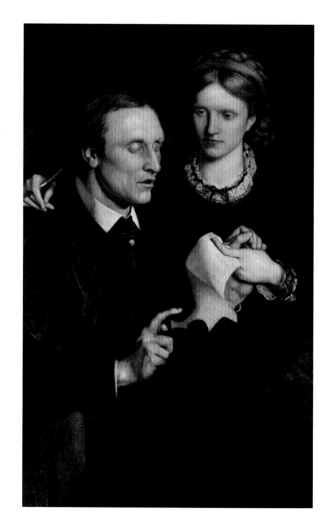

▲ **FIG 82** *Portrait of Henry Fawcett* shown wearing a love knot pin, which became conventionalised into bows, with his wife in 1872. The artist was Ford Maddox Brown, 1821–1893. Henry Fawcett was blinded in a fire-arms accident. He became a Liberal MP and also Professor of Political Economy at Cambridge, and is remembered for his campaign to improve conditions for those who had lost their sight. ©National Portrait Gallery, London. (NPG1603).

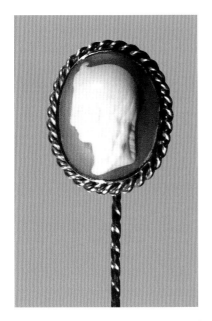

▲ **FIG 66** Italian cameo of a female head carved from a helmet shell, *cassis madagascariensis*, which is a very large sea snail. Possibly carved in Torre del Greco.

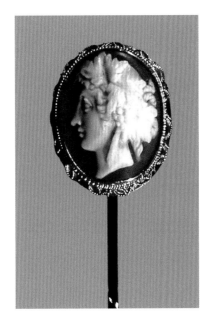

▲ **FIG 67** Italian carved helmet shell cameo of a male head in the form of a tie pin.

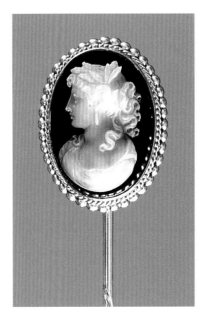

▲ **FIG 68** Tie pin, c.1880, in onyx cameo - many modern designs are now carved by laser.

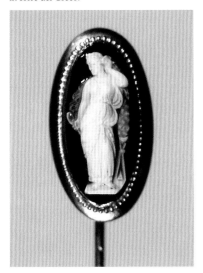

▲ **FIG 69** Onyx cameo of full-length classical female figure holding the mirror of truth and combing her hair, set as a tie pin.

▲ **FIG 70** Tie pin - cowrie shell set in silver showing a ghostly head - sometimes set in reverse as an erotic female symbol.

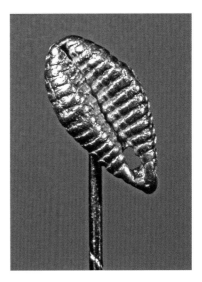

▲ **FIG 71** Cowrie shell modelled in gold and presented as a tie pin with the shell in reverse c.1860. This pin came with a card on which was written in ink *'Part of the tribute money paid by King Kafi of Ashanti (a province of Ghana) to Queen Victoria. Presented by Lady Allen of Hoddenham'*.

FIG 72 Tie pins depicting three insects:

a) beetle in garnet and opal;

b) beetle in amethyst and pearls;

c) a large beetle in hawk's-eye (crocidolite) with ruby eyes.

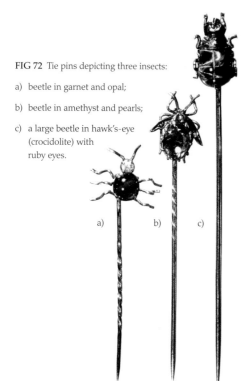

a) b) c)

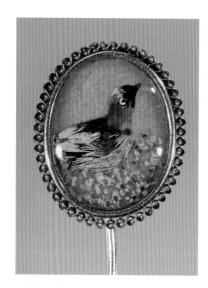

▲ **FIG 73** French pin made from humming bird feathers, on a ground of amber.

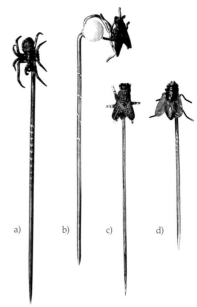

a) b) c) d)

▲ **FIG 74** Four tie pins: a) spider in Austrian cold-painted bronze; b) a fly in tortoiseshell with a pearl; c) a bog oak fly and d) a fly made from horn. After casting and fettling (hand finishing) the surface of the bronze, it may be coloured by the application of various chemical solutions or paints.

▶ **FIG 77** This tie pin shows the serpent super-imposed on an oval of turquoise enamel for true love. The serpent is grasping its own tail: this is a traditional symbol of eternal love. The pin is marked with the French eagle's head for 18ct gold and an indistinct maker's mark, c.1880. Prince Albert gave Queen Victoria a ring in a similar design in the form of a diamond-encrusted snake with ruby eyes, with its own tail in its mouth, thereby forming a uroborus - symbolising unending affection.

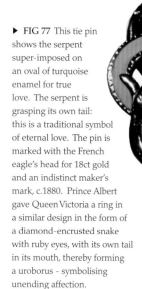

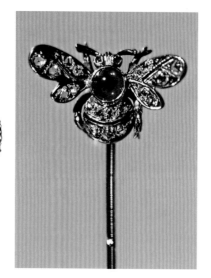

▲ **FIG 75** Tie pin, c.1860, in the form of a bee, in diamonds, sapphire and ruby.

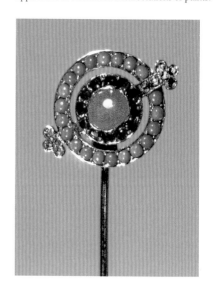

▲ **FIG 76** Sentimental tie pin set as a love token – centre pearl with concentric rings of stones: pearl for purity, ruby for passion, turquoise for love and diamond arrow (Cupid's dart) – for enduring love, c.1860.

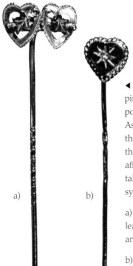

a) b)

◄ **FIG 79** Two heart-shaped tie pins. The heart shape was a very popular Victorian symbol of love. As the heart was thought to be the seat of the soul, it followed that it must be the centre of affection, love and joy. So a heart talisman as a gift was a powerful symbol of love.

a) gold double heart with ivy leaves for fidelity in marriage and two hearts united.

b) polished gold heart with diamond in the centre and engraved decoration, for everlasting love.

◄ **FIG 78** Love token as a serpent with loved one's hair woven into a tube and inserted into the cast body of the serpent which was made into a tie pin. From 1770, hair was used extensively in mourning jewellery and also as a token of happier times of passion. Lord Nelson and Lady Hamilton had jewellery containing 'love knots' made from pubic hair.

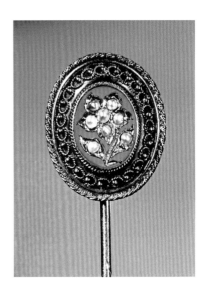

▲ **FIG 80** Tie pin made in gold as a love token, with the motif of a forget-me-not in pearls on a turquoise enamel background. The setting is in cannetille decoration in the form of fine gold twisted wires. This is named after a type of embroidery.

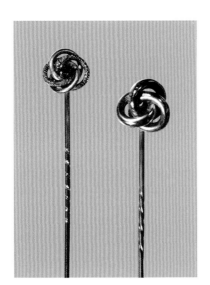

▲ **FIG 81** Two Victorian love-knot tie pins. The knot was used to symbolise the binding together of that which is good and precious. Later, knots were translated into bows.

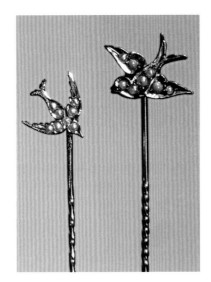

▲ **FIG 83** Two swallows-in-flight tie pins, one inlaid with pearls and the other with turquoise and pearls. The swallow is said to be the messenger of Spring adorned with love and purity.

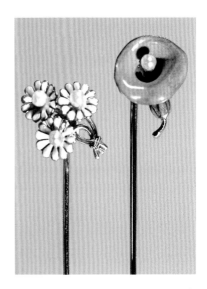

▲ **FIG 84** Tie pins illustrating the language of flowers: convolvulus for affection and the daisy for innocence.

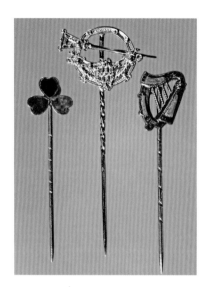

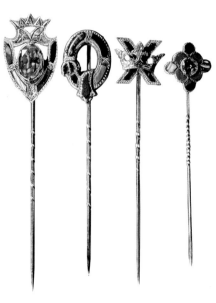

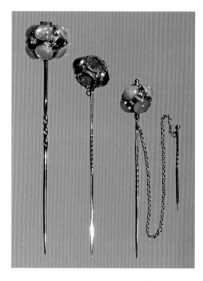

▲ **FIG 85** Three Irish tie pins: shamrock and harp in Connemara marble, gold Tara brooch marked 'Johnson Ltd Dublin 18ct'. An early 8th Century gilt-bronze Irish ring brooch known as the 'Tara' brooch, found in 1850.

▲ **FIG 86** Four tie pins in various Scottish agates and jaspers.

▲ **FIG 88** Three mid-to-late Victorian ornamental tie pins: a) An octagonal opaline paste cube – very convincing opal effect. b) A hexagonal amethyst paste form – very convincing, as the stones show no signs of wear. c) A hexagonal opaline paste form as a double pin.

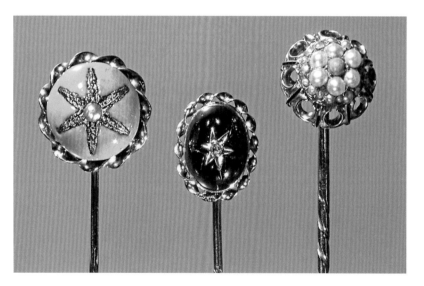

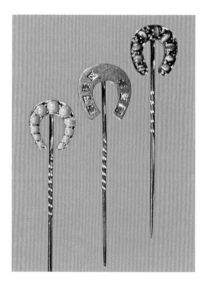

▲ **FIG 87** Three mid-to-late Victorian ornamental tie pins:
 a) Turquoise enamelled dome with pearl centre – love and purity.
 b) Cabochon garnet with hexagonal gold centre star in an engraved setting with diamond centre - for fidelity, cheerfulness and constancy with the diamond for enduring love.
 c) Cushion of pearls with turquoise centre stone – purity and love.

▲ **FIG 90** Three horseshoe tie pins: coral, cat's-eye quartz, diamond and ruby. The horseshoe has long been regarded as a talisman for good luck.

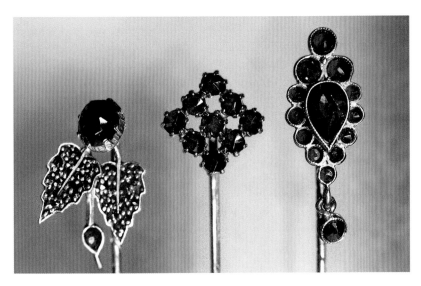

▲ **FIG 89** Three tie pins set with deep red Bohemian pyrope garnets.

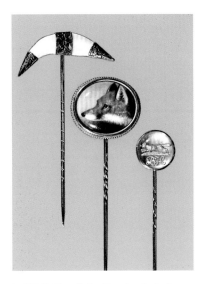

▲ **FIG 91** Three foxhunting pins: fox teeth, fox enamel by W B Ford 1875, and a round pin set for the Master of Foxhounds Bedale Hunt.

▼ **FIG 92** Tie pin of a fox cast in 18ct gold.

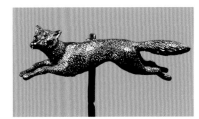

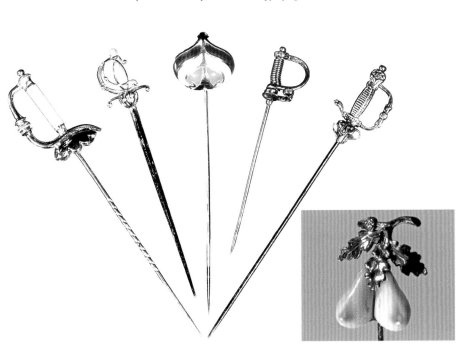

▲ **FIG 95** Five Fencing Club sword pins.

▲ **FIG 94** Austrian deer teeth set as a tie pin, the oak leaves are symbolic of strength.

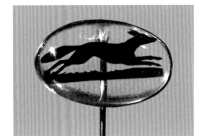

▲ **FIG 93** Fox hunting tie pin with the silhouette of a fox made from black paper.

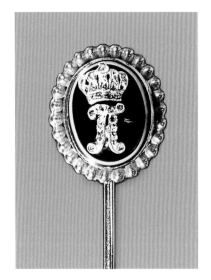

▲ **FIG 96** Prince Albert memorial pin with 'A' in diamonds with Imperial Crown above on an onyx background. Prince Albert died in 1861 and the tie pin has a hinged vertical lid, which when opened, reveals a sepia photograph of Prince Albert.

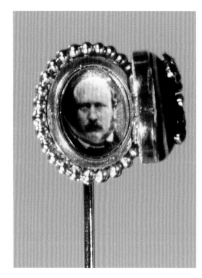

▲ **FIG 97** Photograph of Prince Albert in FIG 96 with hinged lid opened.

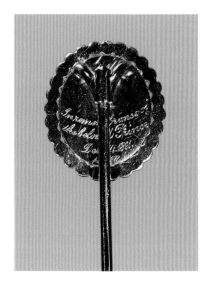

▲ **FIG 98** Engraved reverse of memorial pin FIG 96 *'In remembrance of the beloved Prince Dec. 1861 from VR'*. Queen Victoria distributed many items of jewellery, suitably inscribed, in tribute to her husband Prince Albert.

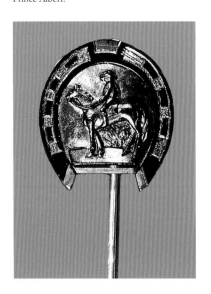

▲ **FIG 100** Jet horseshoe and jockey pin c.1862. After the death of Prince Albert jet was worn universally as mourning jewellery.

▲ **FIG 101** Tie pin in marcasite and black enamel, c.1862.

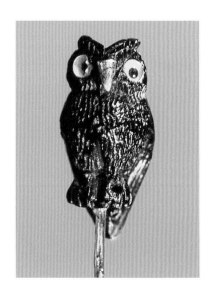

▲ **FIG 102** Tie pin in the form of an owl, made from bog oak, which is wood, mainly oak, that has been preserved in peat bogs.

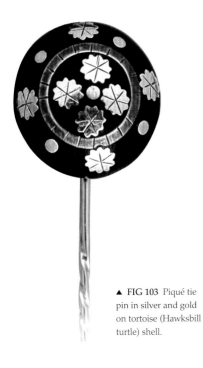

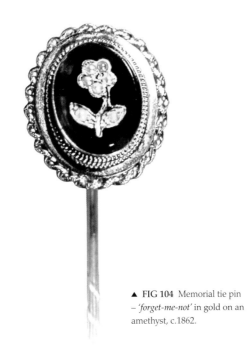

▲ **FIG 103** Piqué tie pin in silver and gold on tortoise (Hawksbill turtle) shell.

▲ **FIG 104** Memorial tie pin – *'forget-me-not'* in gold on an amethyst, c.1862.

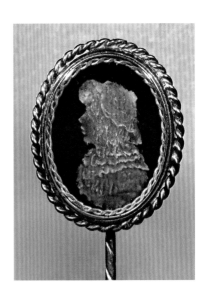

▲ **FIG 105** Memorial tie pins: a) pin with an elaborate oval hair design with twisted gold wire love knots. b) pin with a hinged lid, in the form of a casket containing an intricate hair pattern.

▲ **FIG 106** Memorial tie pin in the shape of a colourful casket with a hair box. The panels are made from goldstone, malachite, jasper and lapis lazuli. Continental c.1880.

▲ **FIG 107** A memorial or sentimental gilt tie pin depicting a young woman wearing a ribboned bonnet and a red flower, carved as a cameo in wax, on a black background, c.1865.

CHAPTER 6

The World moves on with the full flowering of Tie Pins in the mid- and late-Victorian period

Austro-Hungarian Empire – neo-Renaissance - enamels of Essex – Ford – Bailey – Bell – Simpson – reverse carved crystals – Etruscan and Archaeological Styles – Castellani and Giuliano – Suez Canal 1869 – Egyptian Revivalist jewellery – General 'Chinese' Gordon 1870 – pins from India, China and Japan – cabinet of curiosities – French pins – Chinese fruit stone carving – Masonic Pins - carved heads in amethyst, wood and labradorite – Swedish design 1845 – Limoges enamels.

In the mid-Victorian period with changes in fashion, the tie pin was really the only item of jewellery that men could wear. With the restrained style of dress the tie pin could be flamboyant or reserved and show political, sporting, school, university, hunting or military allegiance. It was an almost unlimited opportunity to show the wearer's interests. Although largely a male item of jewellery, it was worn by women under a number of guises and names: dress pin, breast pin, coat pin, collar pin, lapel pin, shawl pin, handkerchief pin; but all were ornamental. As this article of predominantly male jewellery became accepted, its popularity spread across Europe and, to a lesser extent, America. Elegant cravat pins were made in the German states, the Austro-Hungarian Empire, Sweden,

FIG 112 Tie pin of a miniature painting ▶ of a French cavalry officer, c.1870.

Russia, Bohemia, Rumania, France, Italy and Spain. Each country produced characteristic pins, but those from Paris and London seem to have been the most popular. Towards the end of the 19th Century, Cartier, Tiffany and other American jewellers made tie pins of outstanding quality.

From the 1840s the richly decorated dress of men which had been fashionable in the 1800s, gradually gave way to attire that was elegant, but with a restrained use of colour. By the 1860s, day wear had become smart but subdued, while evening wear was an austere elegant uniform. It was only in sports and hunting dress that colour and innovation appeared acceptable. The hunting fraternity wore large white cravats held in place by a variety of ornamental pins with finials of horseshoes, fox heads, fox teeth, horse heads and many more, made in silver and gold.

From the 1850s and '60s, the necktie became the universal item of men's dress, so the tie pin was accepted by all classes as the item of jewellery that could be worn by all male members of society.

During the mid-Victorian period there were two interesting areas of development in tie pins: English carved and painted crystals, and painted enamels. Carved and painted intaglio crystals were an English invention. They were carved in reverse under a dome of rock crystal which slightly magnified the finished work. It is attributed to a seal engraver, Thomas Cook, who worked in Clerkenwell and had numerous pupils. The most important of these was Thomas Bean, whose son Edgar and grandson Edgar, continued the business until 1954 and supplied Hancocks, now of the Burlington Arcade in London. Although reverse engraving was a traditional technique it was the use of oil paint that brought these delicate objects to life by the realistic use of colour and sensitive rendering of light and shade. It was the display of these reverse crystals in 1862 by the London firm of Lambert and Rawling that brought them to the attention of the Illustrated London News and thence to a wider public.

They were made in the traditional manner by cutting away the waste material with copper wheels, simple drills and a slurry of diamond dust. The cutting is usually very deep to give a three-dimensional effect to the model. Birds, flowers, dogs, horses, fish, beetles, bumble bees, butterflies, field sports, coaching scenes and initials were some of the most popular subjects. The painting was very exacting and probably carried out by portrait miniature painters who had lost their livelihood as a result of the invention of photography. The technique involved painting in reverse by putting in the highlights first and working backwards to the final texture. The crystals were then mounted on discs of mother of pearl or placed on a highly polished surface of gold, or on a surface with a natural gold finish that was left matt and termed 'bloomed gold'.

The art of crystal carving spread to France, the United States of America and Germany, where crystals are still produced in the town of Idar Oberstein. A French crystal artist who worked in London created a bumble bee – initialled E M P for E Marius Pradier.

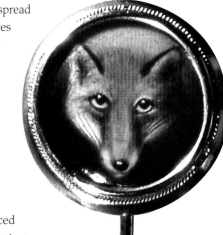

◄ FIG 113
Enamel fox mask tie pin by William Essex, dated 1862.

Not all crystals are produced from rock crystal and collectors should examine the dome most carefully for bubbles, which prove that the dome is made of paste or glass. Many of the paste crystals show very fine craftsmanship but the dome is not as hard as rock crystal. Curved domes were also produced in moulded glass and the carved interiors produced in the same way, with painting that can be very convincing. Strangely, the manufacture of these crystals has been attributed to William Essex (1784-1869). So we have the misleading attribution of crystals as being 'Essex' or 'Wessex'. This is not correct, as William Essex worked as a miniaturist and produced painted enamels (see Glossary). He always signed his work on the back and included the date after his painted signature in Roman capitals. In 1839 he was appointed enamel painter to Queen Victoria and to the Prince Consort. He exhibited at the Royal Academy until his old age. His most famous pupils were his son W.B.Essex (1823–1852), William Bishop Ford (1832–1922) and J.W. Bailey (1831–1914).

However, there were other miniaturists who produced painted enamels but did not sign or date their work, and some who only used a surname. A tie pin of a pig, signed *'Simpson'* may well have been painted by John Simpson (1811 died after 1871). Another enamelled tie pin of a terrier dog, and signed *'Bell'*, may have been painted by William Charles Bell (c.1830/1–1904), who was enamel painter to Queen Victoria and collaborated for some time with J.W.Bailey.

The only counterfeit tie pin seen, up to the present time, is a copy of a William Essex enamel portrait of a dog's head. However, as this was a printed copy of the image, which appeared to have been heavily varnished and set in silver, it was easily detected by examining the image with a good hand lens.

An interesting example of a tie pin in the Austro-Hungarian style, which is often encountered, shows the head and shoulders of a Black African. This figure has been enamelled and has an elaborate jewelled turban. This form was created in Venice and influenced by the employment of African pages and servants by the Venetian aristocracy. This style of tie pin proved so popular that it was copied by craftsmen in the town of Rijeka, now in Croatia.

From the 1870s, the aristocratic and wealthy upper classes wore tie pins of exceptional craftsmanship, value and elegance, made by Cartier, Boucheron, Tiffany, Fabergé, Castellani and Giuliano.

FIG 109 Austro-Hungarian style pin, in enamel and paste, with figure of Black African ancestry, in oxidised silver.

It was also a period of archaeological excavation in the Middle East and Europe. Discoveries by Heinrich Schliermann (1822–1890) and archaeologists working in Italy and Greece, created intense interest and gave rise to the genre *Archaeological Jewellery*, which was inspired by the jewels brought to light by excavations. On the other hand, a working class man, who could afford a few pence, could wear a simple gilt pin with a round head made by the *'Toymakers'* of Birmingham, with his 'best suit' on a Sunday. (*'Toymakers'* were jewellers who specialised in making small items).

So between the two extremes came tie pins of every description. Enamelled tie pins for the young hunter returned from Africa, as well as reverse crystal pins of dogs, horses, fish or flowers, and special pins for societies, clubs and interests. Tie pins were also made in special styles; Archaeological, Art Nouveau, Jugendstil, Arts & Crafts and Art Deco: the list is almost endless, and many of these tie pins were examples of exceptional skill and design.

The emerging workforce of Victorian society needed a form of neckwear that was easy to put on, comfortable and suited to the workplace - the precursor of our modern tie, now held in place with a simple tie pin.

The men in the leisured and upper classes were accepting a radical uniformity with the working class but still maintaining a class difference by the quality of the fabric of the tie itself, tie pins worn, and the cut of their clothes.

Thus there emerged four different new styles of neckwear, all having evolved from various styles of cravat. First, the bow tie evolved from the various knots used for the cravat which could be worn for day or evening dress.

Next, the scarf necktie that was fastened with a scarf ring and was for informal and sports wear. The Ascot was the style accepted for formal wear and hunting, when it was usually white, and firmly held in place by a tie pin. Finally, the four-in-hand or long tie gained in popularity from the 1860s and was held in place by a tie pin. This type of tie used the '*four-in-hand*' knot. This strange expression has an interesting origin. It was the name given to a type of carriage, drawn by a team of four horses, with the harnesses arranged in such a way that the four horses could be driven and controlled by a single driver. It is thought that the carriage drivers fixed their reins with a '*four-in-hand*' knot and also tied their scarves in the manner of a '*four-in-hand*' tie. Among the many driving clubs in London there was the '*Four-in-hand*' Club, established in 1856. Part of the uniform of this group of young men was the wearing of a '*four-in-hand*' tie!

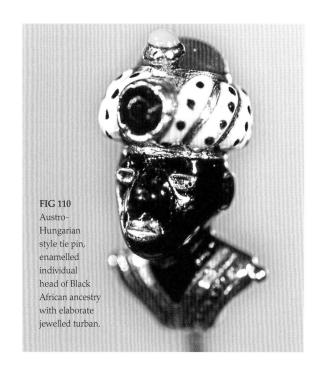

FIG 110 Austro-Hungarian style tie pin, enamelled individual head of Black African ancestry with elaborate jewelled turban.

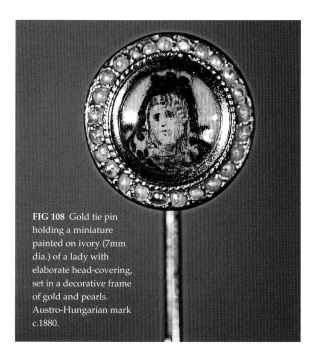

FIG 108 Gold tie pin holding a miniature painted on ivory (7mm dia.) of a lady with elaborate head-covering, set in a decorative frame of gold and pearls. Austro-Hungarian mark c.1880.

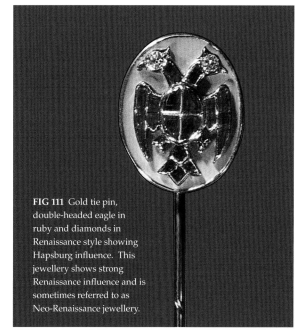

FIG 111 Gold tie pin, double-headed eagle in ruby and diamonds in Renaissance style showing Hapsburg influence. This jewellery shows strong Renaissance influence and is sometimes referred to as Neo-Renaissance jewellery.

FIG 114 ▶
Enamel tie pin dated 1883, of a Rhodesian Ridgeback Hound used for lion hunting. J.W. Bailey (1831–1914) is noted for his animal miniatures and this magnificent pin may have been worn by a young 'buck' at his London Club, perhaps on his return from a successful safari in Africa.

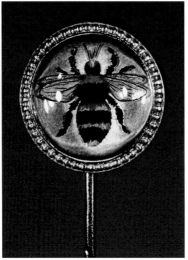

▲ **FIG 116** Carved reverse crystal of a bumble bee as a tie pin. The bee foretells great domestic happiness – they also appeared in combination with a cross in *'don't be cross'* and in erotic symbolism of a bee and a honey pot.

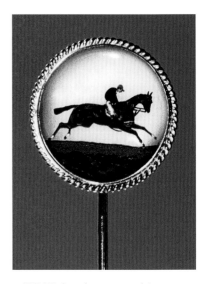

▲ **FIG 117** Carved reverse crystal tie pin of a horse and jockey.

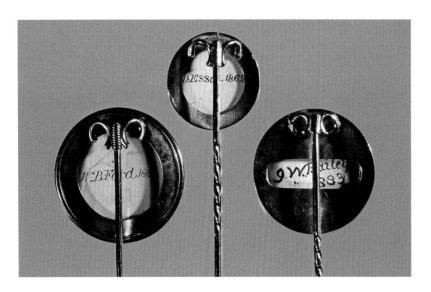

▲ **FIG 115** Signatures of William Essex, W.B. Ford and J.W. Bailey.

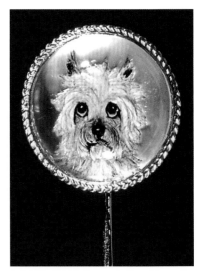

▲ **FIG 118** Reverse carving in crystal of a Cairn Terrier dog.

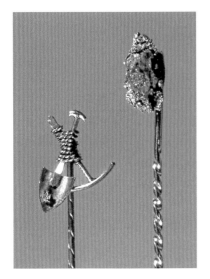

▲ **FIG 119** Tie pin showing a collection of gold mining tools and gold matrix in quartz.

▲ **FIG 120** A gold tie pin c.1875 showing some fine lapidary work using two varieties of goldstone, marble and onyx, all set in an interesting geometric pattern requiring great accuracy in cutting.

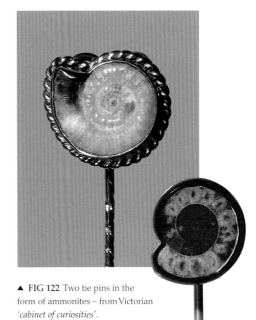

▲ **FIG 122** Two tie pins in the form of ammonites – from Victorian *'cabinet of curiosities'*.

▼ **FIG 121** Three tie pins showing Masonic symbols.

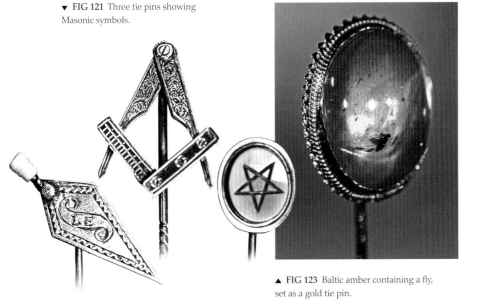

▲ **FIG 123** Baltic amber containing a fly, set as a gold tie pin.

▲ **FIG 124** Stone age arrow head set in gold, as a tie pin.

▲ FIG 125 Operculum – *Turbo petholatus* – also known as *'Chinese cat's-eye'*, set in gold as a tie pin. It is the flap that the snail-like mollusc closes as it retreats into its shell.

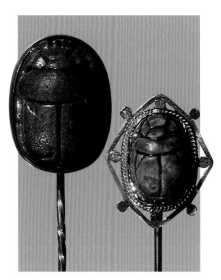

▲ FIG 126 Two Egyptian scarabs set in tie pins – the scarab is the symbol of rebirth. The people of ancient Egypt believed that the Pharaoh would protect them when they were buried. The scarab was also worn by Egyptian warriors for health, strength and vitality.

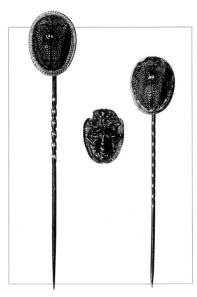

▲ FIG 127 Two tie pins of green beetles (*cassida veridis*) from Brazil and an unmounted beetle showing the lower surface. Jewelled scarabs from Honduras are also highly prized. These beetles have been described as the *'tortoise-back'* variety.

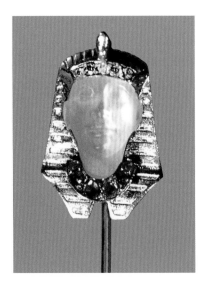

▲ FIG 128 Moonstone carving of a Pharaoh with rubies and diamonds – French, possibly to celebrate the opening of the Suez Canal built by Ferdinand de Lesseps in 1869. This became known as Egyptian Revivalist jewellery.

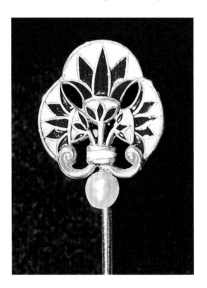

▲ FIG 129 A gold Egyptian revival pin decorated with blue enamel in the form of lotus leaves with a single pearl. The Pharaohs regarded the lotus as the holiest of flowers as it is an emblem of the sun, inducing insight, clarity of thought and wisdom. It represented the goddess Isis and so became an amulet for the preservation of purity.

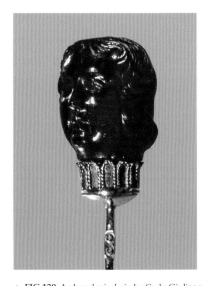

▲ FIG 130 Archaeological pin by Carlo Giuliano (1863–1895), from the Judith H Siegal Collection, in gold and hessonite garnet. The 15th Century hessonite garnet bead is carved in the round as the head of a man, mounted in gold as a tie pin. The decorated collar is signed 'CG'.

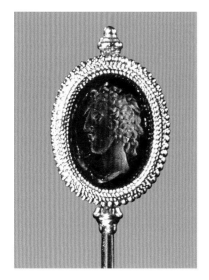

▲ **FIG 131** Tie pin in the style of Castellani: a classical head carved in amethyst.

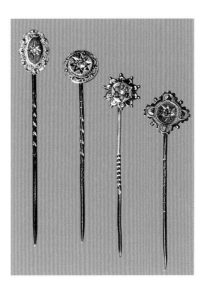

▲ **FIG 132** Archaeological influence: group of four pins showing the influence of Castellani and Giuliano.

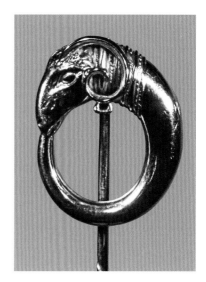

▲ **FIG 133** Tie pin of a ram's head, in the archaeological style, c.1880.

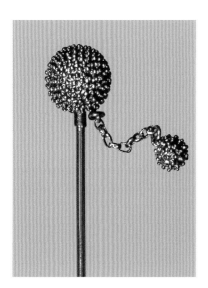

▲ **FIG 134** Archaeological influence on a popular tie pin: ball and chain, showing a form of granulation.

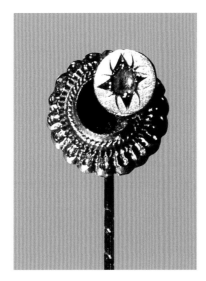

▲ **FIG 135** Archaeological style pin made with secret covered cavity: often referred to as a *'Borgia'* pin.

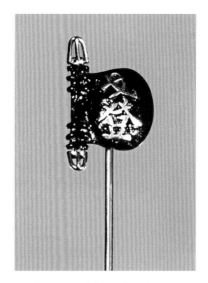

▲ **FIG 136** General *'Chinese'* Gordon tie pin, in the form of a dispatch case, with Chinese symbols for *'Gor–don'*.

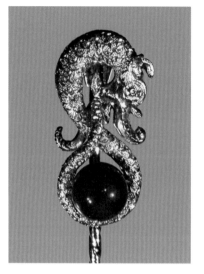

▲ FIG 137 Tie pin showing a Chinese dragon coiled around a lapis lazuli bead: late 19th Century.

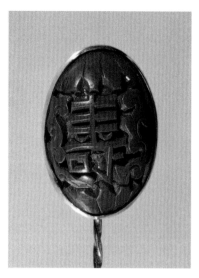

▲ FIG 138 Chinese lacquer tie pin inscribed 'JU - *good fortunes*', made in the late 19th Century.

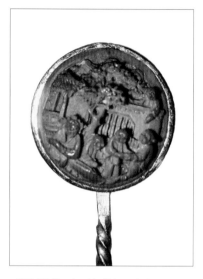

▲ FIG 139 Tie pin with Chinese fruit stone carving depicting a fable - possibly 18th Century. Chien Lung 1711–1799 period. This form of miniature work was popular in China and possibly originated from SUZHOU near Shanghai, and made for the tourist trade. Late 19th Century in very high carat gold.

◀ FIG 140 Japanese metal tie pin made by the damascening process where gold (or silver) is hammered into the iron matrix and known as Kin Numoné Zogan. Made by Komai Brothers, marked KB and from Kyoto Masa, c.1890. In 1876, the Emperor banned the wearing of swords by the Samurai warriors so some sword makers used their skills to make ornamental objects.

▲ FIG 141 Tie pin made from an Indian tiger's claw, c.1890, as a tourist souvenir. The claws are worn as love charms and for general good fortune.

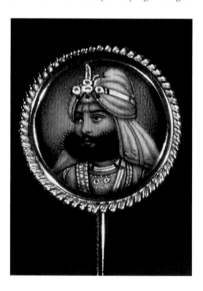

▲ FIG 142 Tie pin made of high carat gold. The miniature painting on ivory is possibly that of a member of the Indian aristocracy.

▲ **FIG 143** Tie pin in high carat gold. The Indian miniature painting on ivory is of the Kutub Mosque, Delhi c.1193 AD.

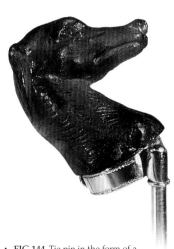

▲ **FIG 144** Tie pin in the form of a greyhound head, carved in amethyst.

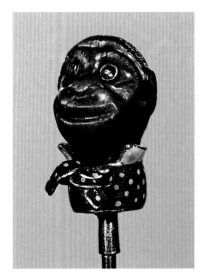

▲ **FIG 145** Gold tie pin in the form of the head of a monkey, made from labradorite, with a blue and white enamel collar, the eyes are collet set rose cut diamonds. French c.1880. In the Far East the monkey symbolises wisdom.

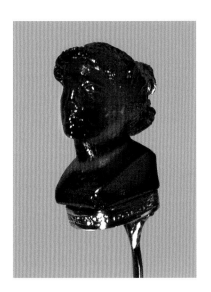

▲ **FIG 146** Classical female head in amethyst-coloured paste – bubbles are visible with a hand lens.

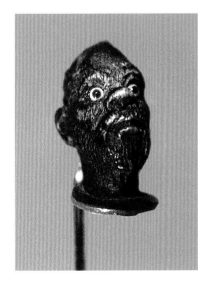

▲ **FIG 147** Head in wood, of an individual of Black African ancestry with onyx eyes.

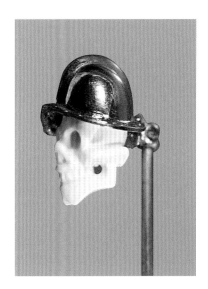

▲ **FIG 148** Tie pin with white coral skull in a combed Morion, 17th Century Italian helmet.

▲ **FIG 149** Silver tie pin in the form of a European Close helmet. c.1570, with an articulated visor and containing a red coral head in the style of Don Quixote.

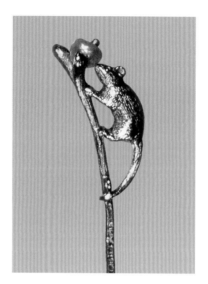

▲ **FIG 150** Gold pin with a harvest mouse showing its prehensile tail and a natural pearl, Swedish marks for Stockholm, 18ct gold and P4 letter for 1845.

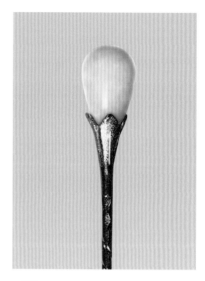

▲ **FIG 151** Opal tie pin with French marks - two crossed swords with a star above and the initials SS for the maker, Salt et Schlosberg. c.1885.

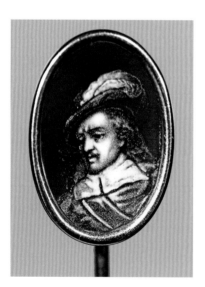

▲ **FIG 152** Limoges enamel tie pin: head of cavalier, white on red background, with French mark.

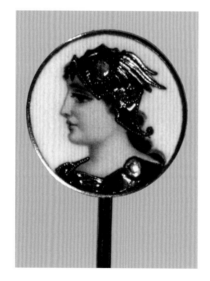

▲ **FIG 153** Painted enamel female warrior's head showing use of gold foil in enamelling and diamonds to enhance the power of the image.

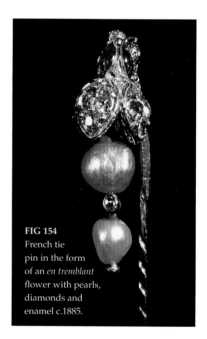

FIG 154 French tie pin in the form of an *en tremblant* flower with pearls, diamonds and enamel c.1885.

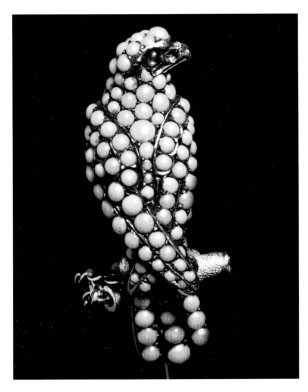

▲ **FIG 156** French tie pin of a sparrow hawk in turquoise, ruby and diamond, similar in style to a pin by Jules Ponce c.1900 in the *Hull Grundy catalogue, page 815.*

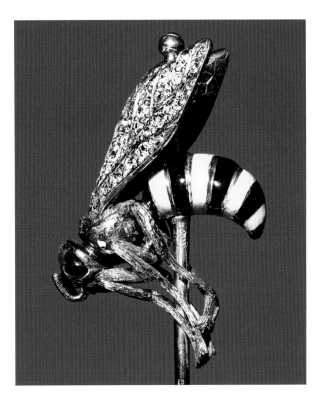

▲ **FIG 155** Front view of French enamel and diamond wasp tie pin c.1910 with four marks: two owls, a boar and a swan. Two owls: French import marks since 1893. A boar: French standard mark for silver and gold since 1905. A swan: stamp for imported silver since 1893.

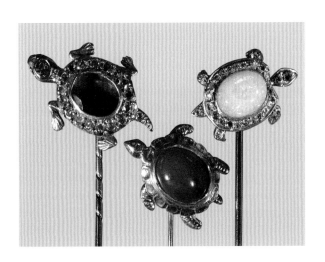

◀ **FIG 157** Three tortoise/turtle tie pins: a) hessonite garnet, b) green jade and c) white opal. These would have been worn as a talisman for endurance, strength and longevity, and, it is also said, to repel black magic.

CHAPTER 7

New Movements

Arts & Crafts – Artist's palette – Mürrle Bennett – Liberty & Co – Art Nouveau – Jugendstil (Youth Style) – Belle Époque – Edwardian – Art Deco – Tutankhamün 1922 – Georg Jensen – Suffragettes GWV – Primrose League – new group pursuits, cars and all forms of sporting activities - Fred Archer.

In the late Victorian period began the evolution of precise *'movements'*, or elegant periods of social development, which have been given descriptive titles.

After The Great Exhibition of 1851, there were eminent artists and designers who considered the quality of designs there to have been quite monstrous and William Morris particularly, declared that artefacts should be handmade without the use of machines, fit for their purpose and produced by honest craftsmen and women.

Consequently, the Arts & Crafts movement developed in the 1880s as a reaction to the tasteless machine-made goods produced earlier in the century. The main supporters were John Ruskin and William Morris who both felt that designs and manufacture had lost the honesty and dignity of the artist craftsman, whose products had been made entirely by hand, based on the belief in the quality of natural materials and fitness

FIG 163 Two designs of tie pin by Mürrle Bennett ▶ and Co (1884–1914), the firm founded by a German, Ernst Mürrle and an Englishman, Mr Bennett, made for Liberty & Co. Their designs show influence of German Jugendstil (youth style – Art Nouveau) and the more abstract jewellery designs of the Arts & Crafts movement.

for purpose, as found in the Medieval Guild system. William Morris was very critical of The Great Exhibition of 1851 and felt it was the height of bad taste and *'contained tons upon tons of unutterable rubbish'* - harsh words when the original title was *'The Great Exhibition of the Works of Industry of all Nations'*.

In 1888 the Guild of Handicraft was founded on Utopian ideals, by Charles Robert Ashbee, and influenced design in Britain and abroad. Although the Guild was dissolved in 1908 its educational principles were carried on by two important Teacher Training Colleges: Shoreditch and Loughborough. These Colleges used handicrafts as the basis of a liberal education, but have now been absorbed by the Departments of Education of the Universities of Brunel and Loughborough.

The firms of Liberty & Co., Mürrle Bennett and Charles Horner of Halifax, produced jewellery based on traditional hand-crafted designs using enamel, ornamental stones, paste and mother of pearl. Many tie pins of this period have a medieval appearance, although the influence of Art Nouveau and Celtic forms found in the Cymric range produced for Liberty & Co. is evident. However, some of the tie pins made by Arthur Gaskin and his wife Georgina at the Birmingham School of Art, show a strong Persian influence.

Unfortunately, many Arts & Crafts pieces were not marked and have therefore to be identified by style and design.

During this period, political events, such as the emancipation of women, were also represented in the design of tie pins, but there is some confusion about the authentic suffragette pins worn by men sympathetic to this cause.

Some writers suggest that the tie pins with three links of a chain represent the solidarity of the suffragette movement, but chains and locks were also traditional romantic symbols suggesting *'unchain my heart'* and *'you hold the key to my heart'*, and so are unlikely to be suffragette symbols. The most prominent suffragette organisation in England was The Women's Social and Political Union, the WSPU, founded in 1903 and led by Emmeline Pankhurst (1858–1928). The WSPU did issue a silver brooch incorporating the Houses of Parliament Portcullis symbol, designed by Sylvia Pankhurst, the daughter of Emmeline. The colours used by this organisation, often seen in jewellery, were Green, White and Violet for *'Give Women Votes'* but in America it was Green, White and Red for *'Give Women Rights'*.

Another example of special tie pins embodying an appropriate symbol were those made for the Primrose League, an organisation for spreading Conservative principles and to raise funds for the Party. It was founded in 1883, remained active until the mid-1990s, and was finally disbanded in December 2004. The primrose was known to be the favourite flower of Lord Beaconsfield (Benjamin Disraeli) and the League and the flower became associated with him.

◀ **FIG 166** Delicate gold flower fairy face in enamel, surrounded by flower petals with a diamond droplet. Art Nouveau period with French marks, c.1905.

As a tie pin it is not difficult to find and exists in two forms: one is a very small, dainty gold and yellow enamelled flower, the other is a larger enamelled yellow flower with 'PL' in the centre.

At this time, most organisations sported a tie pin of some type, often in silver or gilded base metal: for example, the CTC (Cyclists Touring Club), athletics clubs, football and cricket clubs, tailors, car clubs of all types including steam cars - the list is almost endless.

Soon after the Arts & Crafts movement began, the Art Nouveau style was emerging, again as a reaction to the vulgarity of machine-made products. By the 1880s the style had evolved under the influence of René Lalique into fluid female forms and flowing hair. The name is derived from a gallery for interior decoration, opened by Samuel Bing in Paris in 1896, called *La Maison de l'Art Nouveau*.

The works of William Morris, Burne-Jones, John Ruskin and later, Charles Ashbee, spread to the continent and fuelled the Art Nouveau movement, which became inter-linked with the Arts & Crafts movement, resulting in free-flowing designs, the intertwining of natural forms using flowers, butterflies, human forms and female faces with flowing hair. It was greatly influenced by Japanese art first seen in Europe in the 1860s.

Some recent research by Dr. Fritz Faltz, the former Director of the Schmuck Museum in Pforzheim, suggests that the owners of small jewellery factories in Pforzheim became aware of the financial importance

of the changing fashions and tastes of their potential clients in Europe, and the popular development of Art Nouveau jewellery was a strong incentive for them to produce items of jewellery in a similar style. This resulted in Jugendstil jewellery, the German interpretation of Art Nouveau, reaching, and succeeding in, all parts of Europe. As most of this jewellery was unmarked, it may be confused with items of French manufacture, but for the collector it is fortunate that most of the Jugendstil jewellery was relatively inexpensive and so is unlikely to be mistaken for the more exclusive Art Nouveau French jewellery.

Thus we have a style that flourished in France and England spreading throughout Europe between approximately 1890 and 1910, but which then began to lose its way and had almost disappeared by the start of the First World War.

After the death of Queen Victoria in 1901, but before the start of the First World War in 1914, there was a brief period that became notorious for its ostentation and public display of wealth. This was the Edwardian period 1890–1914, which had its beginning in the late Victorian era when Edward was Prince of Wales.

On the death of Queen Victoria, her eldest son, Edward, came to the throne at the age of 56. He had already begun to lay the foundation of a society given over to luxury, elegance and pleasure. Tie pin designs flourished at this time using diamonds as the most popular gemstone of this period. Very large diamonds were set in tie pins to represent, for example, a champagne glass, the hull of a ship, or were carved into a horse's head and even to represent a bath with gold taps and claw feet!

Small diamonds were used to frame miniatures, large gemstones and other special items of jewellery.

This period coincided with the French Belle Époque or 'fine period', which had jewellery in the form of garlands and swags of foliage with lace and bows. Much of this fine jewellery would have been impossible to produce without the introduction of platinum, which, although it had been displayed at The Great Exhibition of 1851, had not been used by jewellers because of the technical problems of heating and soldering. Platinum is much harder and stronger than gold or silver and so ideal for the display of small diamonds in sprays, claw settings, millegrain and filigree designs made possible by technical improvements.

The Vienna Secession Movement was a reaction to the naturalism of Art Nouveau and introduced a more geometric style that gave rise to Art Deco after the First World War of 1914–1918. The abstract and geometric composition of Art Deco tie pins developed in the 1920s but had almost disappeared by the start of the Second World War in 1939. The discovery of Tutankhamün's tomb in 1922 then made relatively inexpensive tie pins, modelled on ancient Egyptian styles, very popular. Abstract painting, the rise of cubism and the Paris Exhibition of Decorative Art in 1925 also had a considerable influence on jewellery design.

One jeweller whose style almost transcends these various periods is Georg Jensen (1866–1935).

◄ **FIG 170** Georg Jensen 2007 Heritage Collection – Georg Jensen (1866–1935) Danish Silversmith. The present Company has returned to the Archive Collection to reproduce a tie pin, originally made in 1910, for the 2007 Heritage Collection.

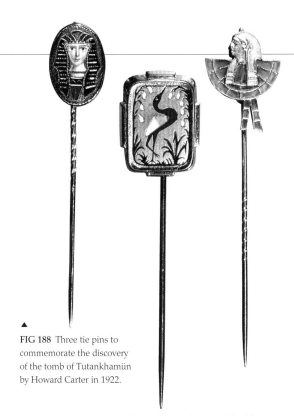

FIG 188 Three tie pins to commemorate the discovery of the tomb of Tutankhamün by Howard Carter in 1922.

He had a deep love of silver and this enabled him to express himself in a unique and original manner though with some inclination towards Art Nouveau. The few pins he made range from typical Jensen design to those using gold and diamonds. The Georg Jensen company in Copenhagen has been producing a Heritage Collection for some years by selecting an item from the Jensen Archive for limited reproduction - for example, in 2007 a tie pin, originally made in 1910, was reproduced. It is in the form of a flower, made in silver and shaped like a stylised bluebell. The company also had a flourishing establishment in America which produced tie pins designed by Georg Jensen.

The years of luxury and ostentation came to an abrupt end in 1914, and when the War ended in 1918 there was a great change in the social order. The wearing of long ties and tie pins continued for some time after the First World War, but the use of the tie pin became less popular, until it all but disappeared just before the Second World War.

After that War only a few dedicated men and women, who saw tie pins as superb examples of jewellers' skills, still wore them, but the long tie is worn today for smart and informal dress. The use of the *'four-in-hand'* knot has declined and the Windsor knot has now become more popular.

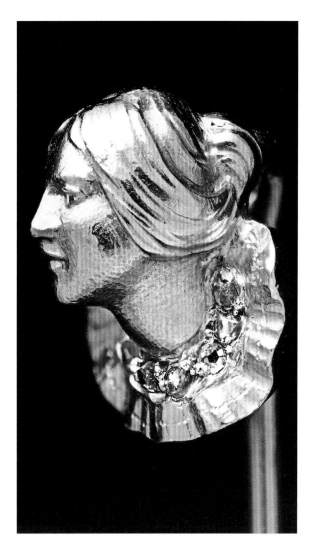

▲ FIG 168 French tie pin c.1900 by André Rambour (1847-1919) with his maker's mark of an apple, his initials AR and the eagle's head.

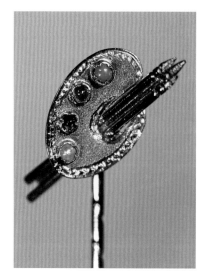

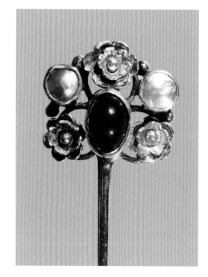

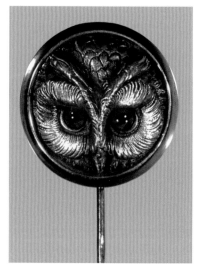

▲ FIG 158 Tie pin in the form of an artist's palette, c.1880 showing the artist's colours as cabochon gemstones of pearl, emerald, ruby and turquoise – for purity, hope, passion and love.

▲ FIG 159 Arts and Crafts Movement pin - three stylised flowers with green chalcedony and two pearls c.1895.

▲ FIG 161 Pin in the form of the head of an owl, in silver with bead eyes, repoussé and chased feather design, c.1890.

FIG 160 Gaskin designers Arthur (1862–1928), Georgina (1868–1934) showing Persian influence, with single turquoise matrix central stone and three pieces of mounted mother of pearl. Some of their work was made for Liberty & Co and called '*Cymric*' jewellery, c.1895. The small pin is in the Arts & Crafts style.

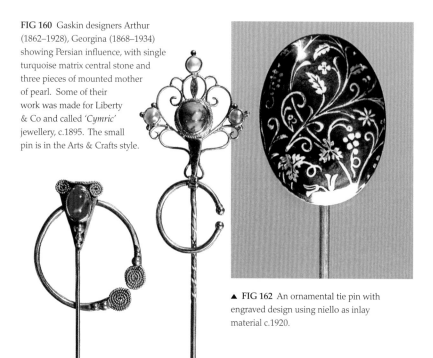

▲ FIG 162 An ornamental tie pin with engraved design using niello as inlay material c.1920.

▲ FIG 164 Four tie pins of Jugendstil designs, created as a German interpretation of Art Nouveau, probably made in Pforzheim.

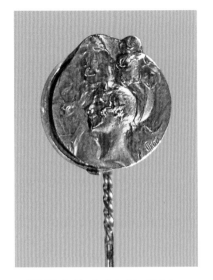

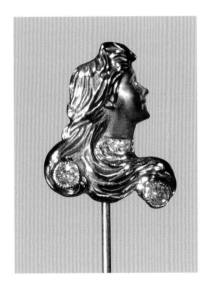

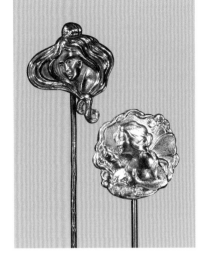

▲ **FIG 165** Parisian Lady by Jules Chéret (1836–1932). French pin with front panel sliding to reveal a concealed space for a secret portrait or erotic photograph, c.1890.

▲ **FIG 167** Art Nouveau group of pins - French style of decoration which had its beginning in the 1860s with the influence of Japan.

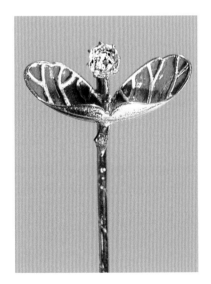

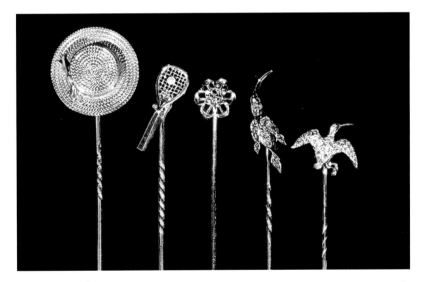

▲ **FIG 169** French tie pin in the form of enamelled plique-à-jour mistletoe leaves and a diamond berry. The leaves may be interpreted as a kiss with the diamond representing the berry for enduring love.

▲ **FIG 171** Belle Époque coincided with the Edwardian Period of great wealth and ostentation. French for 'fine period' found at the end of the 19th Century and the beginning of the 20th. Boater in gold and enamel, tennis racket with calibre set rubies for the handle and a pearl for the tennis ball, an old cut half carat diamond in a floral surround, a flower set with diamonds and a snipe with pavé set diamonds.

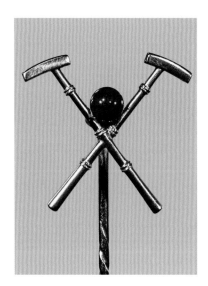

▲ **FIG 172** A gold tie pin of two polo mallets with a lapis lazuli ball, showing a sporting interest of c.1880.

▲ **FIG 173** Tie pin worn by members of the Primrose League, an association supporting the Conservative Party, founded in 1883 and named after Lord Beaconsfield's favourite flower.

▲ **FIG 174** A Suffragette symbol thought to be three strong links in a chain, set as a pin, to show support for the Suffragette Movement but may also be a symbol for the *'chain of love'*.

▲ **FIG 175** Cricket tie pin, consisting of gold stumps with cricket bat inlaid with eleven rose cut diamonds and a ruby ball, c.1880.

▲ **FIG 176** Marquise-shaped tie pin with thirty-four faceted diamonds surrounding a blue enamelled centre with an enamelled white painted naked female holding a hoop, c.1890.

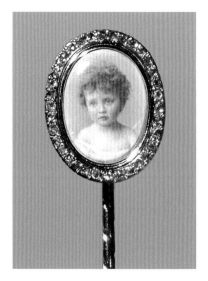

▲ **FIG 177** Delicate miniature painting of the head of a child, encircled by diamonds and set as a tie pin c.1900.

◀ **FIG 180** Four tie pins that could be purchased from the many jewellery catalogues available in late Victorian times. In the Moore & Evans catalogue of 1898 from Chicago, it was even possible to purchase a revolver from the jewellery section. The pearl would signify purity and the ivy leaf fidelity in marriage.

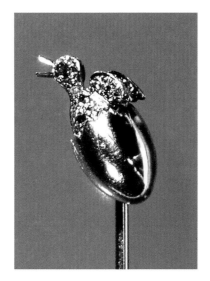

▲ **FIG 178** Tie pin in the form of a duckling, set with pavé diamonds, emerging from a gold egg.

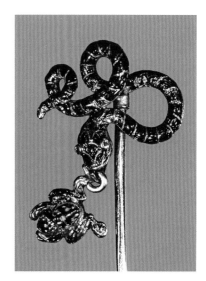

▲ **FIG 179** Green enamelled serpent with a frog suspended from its mouth presented as a tie pin. The serpent is generally regarded as a protecting influence. The Japanese believed that the frog attracts good fortune and as the symbol of Aphrodite it is thought to promote harmony. The frog is the symbol of health and long life c.1925.

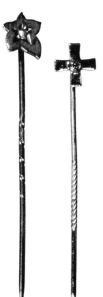

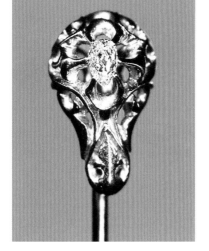

▲ **FIG 181** Gold tie pin designed as an abstract head of a horse, with an old cut pear-shaped diamond c.1900.

▲ **FIG 182** Gold yacht tie pin with rhodochrosite and quartz sails, with included flakes of gold.

▲ FIG 183 Fred Archer (1857-1886) jockey tie pin. He was the greatest Victorian jockey of the 19th Century. He won 2,748 races including the Derby five times. He shot himself while ill with typhoid fever, aged only 29. The reverse side shows the Derby winner *'Ormonde'*.

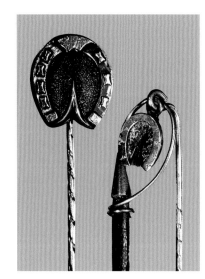

▲ FIG 184 Two silver horseshoe tie pins, one with a hoof, an anchor hallmark for Birmingham with the letter *'h'* for 1882 and a maker's mark JA. The other is a horseshoe on an ebony hoof with a silver whip and ebony handle.

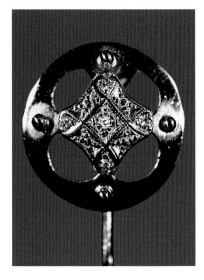

▲ FIG 187 The centre of this pin was an Art Deco engagement ring, converted into a tie pin, with a Celtic form surround. Many tie pins have been made into rings whilst old buttons and single earrings have also been converted into tie pins. It is interesting to examine the back of an old brooch to look for signs of a previous tie pin attachment.

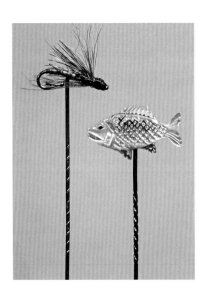

▲ FIG 185 Trout fly on a gold hook and a fish shape in mother of pearl set as tie pins – fitting talisman for abundance!

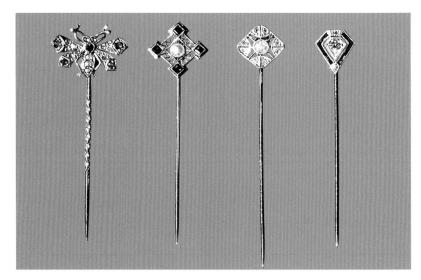

▲ FIG 186 Group of Art Deco pins. The term comes from the French, *arts décoratifs*, which was the title for the Paris Exposition Des Arts Decoratifs in 1895. Characteristics of this style are geometric forms and highly finished surfaces.

CHAPTER 8

Royal Pins and Great Names

*Fabergé – Cartier – Tiffany – Boucheron – Prince of Wales' feathers –
Edward VII & Alexandra – Queen Emma, Dutch Royal Family –
pin given to Queen Victoria's Physician by the Duke of Connaught –
Aristocratic Arms – John Brown pin.*

Tie pins made by Fabergé, Falize, Castellani, Giuliano, Boucheron, Tiffany and Cartier are exceptional examples of the jewellers' art. The life of Peter Carl Fabergé is very well documented and a number of establishments specialise in the sale of his superb artefacts. Sadly, there are very few permanent exhibitions of his works. Over the years the Victoria and Albert Museum has had exhibitions of Fabergé and in 2003 Her Majesty the Queen had an exhibition of Fabergé items from the Royal Collection. In 2006 a remarkable exhibition of 'Fabergé and the Russian Jewellers' was mounted at Wartski, London, in aid of The Samaritans charity. A number of tie pins were on show in the exhibition, including a legendary one given to Harry S. Saward, the stationmaster at Wolferton, Norfolk when Tsarevitch Nicholas II of Russia came to Sandringham in 1894. This imperial gold tie pin by Fabergé is in the form of a laurel wreath framing a diamond-set Romanoff crown. It is signed with the initials of Alfred Thielemann St Petersburg (c.1894) and is contained in its original red leather box; the lid is gold stamped with the Imperial eagle. Boxes of red leather were only presented when the contents were a personal gift from the Tsarevitch Nicholas.

Paris in the second half of the 19th Century saw the rise of many artists, musicians and jewellers. Jewellery makers, including in the 1840s the family of Falize who began to produce jewellery in a distinctive style, Cartier, who was working in 1847, Boucheron in 1858, Lalique in 1885, were all held in high regard. Although the design books of Alexis Falize show many tie pin designs, some with additional notes made by his son, Lucien Falize, tie pins by this dynasty of jewellers are extremely rare.

The company of Cartier was founded in Paris in 1847 by Louis François Cartier (1819–1904). As the company prospered it opened branches in London and New York. Tie pins of great distinction were made and marked *Cartier, New York, London, Paris*. The capital city named immediately after the name of Cartier usually denoted that of the country of origin where the jewel was made.

In America, the leading jewellery designer and manufacturer was Tiffany & Co., founded by Charles Lewis Tiffany (1812–1902) in New York. In 1902 the company was taken over by his son Louis Comfort Tiffany (1848–1933). It made exquisite jewellery in a style popularised in Europe, and has produced tie pins of great distinction.

◀ FIG 193
Tie pin – Russian Imperial double-headed eagle in silver with 84 zolotnik mark. Fabergé made similar pins given to the Imperial Guard by the Tsar Nicholas II.

Frédéric Boucheron (1830–1902) began making jewellery in quite a modest way but quickly established a very successful business in Paris in 1858. The business was carried on by his son Louis and in 1907 an establishment was opened in London.

Between 1870 and 1889 Frédéric Boucheron created an outstanding collection of tie pins for Comte Nisim de Camondo, and these may be seen at the Musée Des Arts Décoratifs in Paris.

From the illustrations at the end of this chapter, it is clear that tie pins were held in high regard as presents in royal and aristocratic society. Tsarevitch Nicholas II gave them as diplomatic gifts; Edward, Prince of Wales, gave them as presents before his Coronation in 1906 and his brother, the Duke of Connaught, presented them for services to Queen Victoria. Other European Royal Houses had special tie pins made, and in the Dutch Royal Collection there are several examples which were presented by Queen Emma, the second wife of King William of the Netherlands (1858–1934), the great-grandmother of Her Majesty Queen Beatrix. These tie pins, with the crowned monogram E, were made in gold and silver, sometimes decorated with small gemstones and all in the same gold-tooled, maroon leather cases bearing the Royal crown. Edward VII and Queen Alexandra also presented tie pins as diplomatic gifts.

However, it was Queen Victoria who seemed to view tie pins as highly personal gifts. On the death of Prince Albert in December 1861, she presented tie pins to very senior members of the Royal household with an engraved personal message, signed 'VR'. During his service to Prince Albert as personal ghillie, or Highland servant, John Brown accumulated a

large collection of gifts from Queen Victoria including a number of tie pins. On John Brown's death in 1883 a memorial tie pin recording the date was designed by Her Majesty for presentation to her Highland servants and cottagers: this pin to be worn on the anniversary of his death. The pin bore a circular gold disc with a cameo portrait in profile of John Brown, his initials, the date of his death and on the reverse, in cypher, 'From VRI', *Victoria Regina Imperatrix*, the title Queen Victoria adopted after she became Empress of India in 1876.

Another tie pin of exceptional design and craftsmanship has an oval aperture enclosing a photograph of John Brown within a border of graduated, banded, onyx cabouchons forming the body of a serpent framing the photograph, with the tail wrapped behind the head. The banded onyx cabouchons have all been orientated and set pointing towards the photograph of John Brown. On the reverse is inscribed, in cypher "From VRI, 1895 F.C." Although John Brown died in 1883 this was possibly a gift from Queen Victoria to John Brown's cousin, Francis Clark, who assumed the title *'The Queen's Highland Servant'* on John Brown's death. The date of 1895 may have some significance; possibly to mark a retirement or special event?

Members of the British aristocracy also had tie pins made bearing their armorial and heraldic devices, but these pins are rarely seen by the collector as they usually remain within the family.

◀ **FIG 203** Tie pin presented to Sir Philip C Smyly MD by HRH The Duke of Connaught, (son of Queen Victoria) when Sir Philip was appointed Physician to the Queen. This tie pin, with the royal crown at the top, surmounts a central oval showing the initials of the Duke as entwined 'A. W' for Arthur William, under a quartz dome surrounded by pearls, sapphires, diamonds and blue enamel, dated 1892.

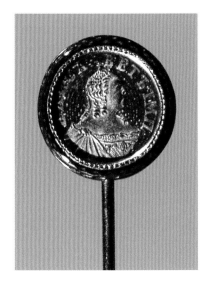

▲ **FIG 189** Tie pin - Carl Fabergé an enamelled half rouble 1756 of Elizabeth, Empress of Russia (1709–1762), ruled from 1741-1762, strawberry coloured enamel over a guilloché ground. Workmaster Erik Augustus Kollin of St Petersburg c.1895; 56 zolotnik = 14 carats.

▲ **FIG 190** Tie pin – an enlargement of Carl Fabergé marks (FIG 189).

NB. Image very similar to Catherine the Great (1729-1796) who ruled from 1762-1796.

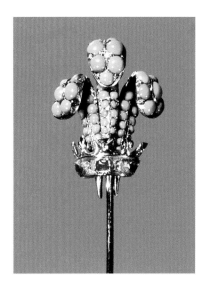

▲ **FIG 194** Tie pin, c.1860, 18ct gold Prince of Wales' feathers set with turquoise above an Imperial Crown.

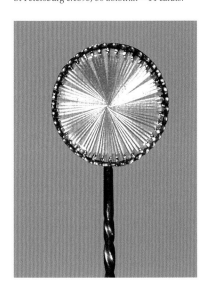

▲ **FIG 191** Carl Fabergé tie pin set with circular enamelled disc, decorated sky blue over a sunburst guilloché ground, and signed *'Fabergé Moscow'*, c.1900. Assay Master's marks are for Ivan Lebedkin.

▲ **FIG 192** Close up of marks on pin (FIG 191).

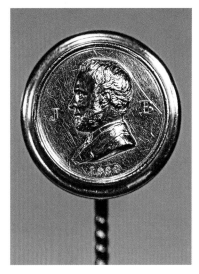

▲ **FIG 195** A memorial tie pin for John Brown, who died in 1883, designed and presented by Queen Victoria to her Highland servants.

▲ **FIG 196** A tie pin box made by M. Rettie & Sons, Jewellers, Aberdeen for (FIG 195).

▲ **FIG 197** A tie pin - an enamel portrait by J W Bailey, of Princess Alexandria, Princess of Wales (1844-1925), age 19 at the time of her marriage to Edward, Prince of Wales in 1863.

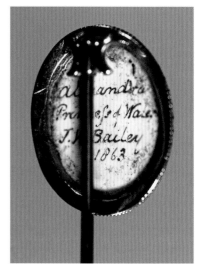

▲ **FIG 198** The inscription on the reverse of the Princess Alexandria tie pin (FIG 197).

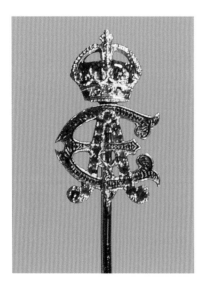

▲ **FIG 199** Tie pin, c.1905, an 18ct gold mounted Royal Presentation pin with royal insignia of Edward VII and Queen Alexandra. Green enamel for the 'E' and 17 eight-cut rubies to form the 'A'. These Presentation pins were often made in various grades, with the highest grade using very fine materials.

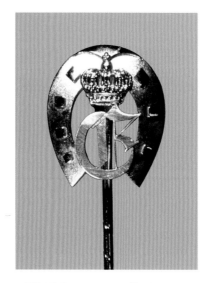

▲ **FIG 200** Tie pin - presented by Queen Emma of Waldeck-Pyrmont (married 1879) the second wife of William III of The Netherlands (1858–1934). Gold horseshoe – letter 'E' with a royal crown – possibly presented at a horseshow. Queen Wilhelmina, William's daughter by Emma, succeeded to the throne on his death.

▲ **FIG 201** Box with matching insignia on lid for Queen Emma of Waldeck-Pyrmont, pin (FIG 200).

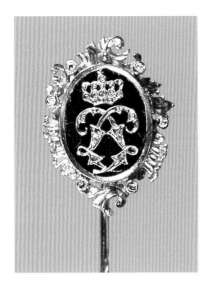

▲ **FIG 202** Tie pin showing the coronet of an Earl with five 'pearls' raised on tall spikes, alternating with four strawberry leaves. The elaborate initials are on an enamelled, mazarine blue background, picked out with six rose cut diamonds. The gilded embellishment around the central shield is interspersed with six rose cut diamonds, c.1880.

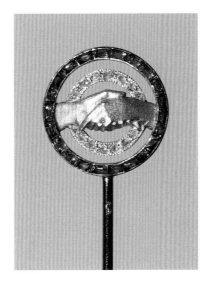

▲ **FIG 204** Cartier tie pin celebrating an engagement, with male and female hands and ring surrounded by diamonds and calibre sapphires: diamonds for forever: sapphires for peace and happiness. Two hands clasped together stand for concord and friendship and, in this design, would represent constancy.

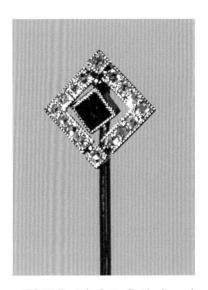

▲ **FIG 205** Tie pin by Cartier (Paris) - diamond and sapphire lozenge-shaped cluster with a central suspended square-cut sapphire. French marks - an eagle's head and maker's mark.

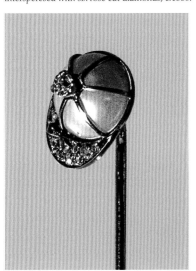

▲ **FIG 206** Tie pin by Tiffany using a baroque pearl to represent a jockey's cap.

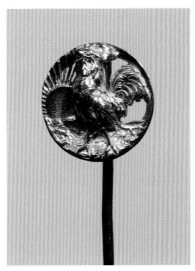

▲ **FIG 207** Tie pin by Frédéric Boucheron, 1830-1902, a leading French jewellery firm, using the popular theme of a cockerel and the rising sun. The pin is marked '1862', has a horizontal diamond-shaped lozenge with a maker's mark and the eagle's head, indicating it was made in France between 1847-1919.

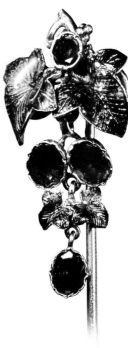

◀ **FIG 208** A gold tie pin by Jules Wiese, (1818–1890), Paris, modelled on a fruiting vine with green enamel leaves and articulated flat garnet grapes. French mark and signed, c.1875.

CHAPTER 9

Tie Pins of the late 19th & early 20th Centuries

Typical tie pins worn by young men – Tunbridge Ware – Stanhope (Niagara Falls descent in barrel by Annie Taylor in 1901) in satinspar – erotica – Not for Joseph – Nobody's Child – Monkey King – flexible fish – Edwardian novelties – plough – trade associations – modern pin in old style – War wound pins – Spitfire - Concorde.

So we approach the end of the journey with finally, a period of amazing ingenuity, bizarre interpretation and the extreme recording of every craft, happening, saying, machine or historical event that it was possible to record. Quite simply, if it could be articulated, then a creative jeweller of the time would translate the idea into a practical tie pin to possibly be worn by some of the 'bright young things' of the new Century.

From the descent of the Niagara Falls in a barrel, through every possible club activity, to the recognition of *'severe war wounds'*, all would be celebrated as tie pins.

Perhaps the final passing of that wonderful supersonic aircraft *'Concorde'* is a fitting valediction for the history and development of cravat pins and tie pins as masterpieces of the jewellers' art.

▶ **FIG 238** Modern tie pin with a 18th Century zigzag stem, in the form of a bizarre insect with blue paste body and red paste eyes

▲ **FIG 230** A spark plug tie pin with trade associations and a silver engraved tie pin of a steam traction engine c.1880.

▲ **FIG 241** Modern tie pin in silver, of the legendary Supermarine Spitfire, designed by R.J. Mitchell.

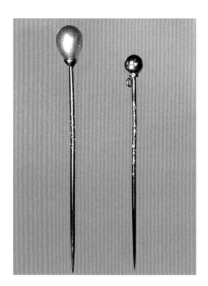

▲ **FIG 209** Two typical tie pins worn by young men, one a gold ball at the head of the pin and the other an imitation pearl.

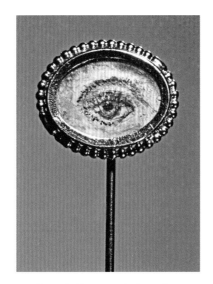

▲ **FIG 210** Gold tie pin in the form of an eye miniature c.1870. George IV is said to have proposed marriage to Mrs Maria Fitzherbert in 1785 and presented her with a miniature painting of his eye. During the 19th Century there was a brief vogue for eye miniatures; perhaps interpreted as catching an *'intimate glance'* or *'keeping an eye on you'*.

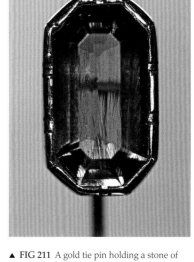

▲ **FIG 211** A gold tie pin holding a stone of gemmological interest, called a 'Moldavite'. This is a silica glass, first noted in 1787 near the Bohemian river *'Moldau'*, a river for which the Czech name is *'Vltava'*.

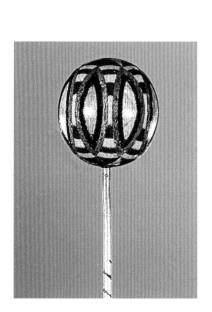

▲ **FIG 212** Tie pin – Tunbridge Ware has been in existence long before the mosaic decoration developed in the 1820s. Originally, it was produced by craftsmen at Tunbridge Wells in Kent. This tie pin may have been made by the Wise or Fenner family who produced items by turnery, but there were many craftsmen working at this trade.

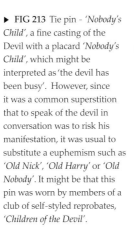

▶ **FIG 213** Tie pin - *'Nobody's Child'*, a fine casting of the Devil with a placard *'Nobody's Child'*, which might be interpreted as 'the devil has been busy'. However, since it was a common superstition that to speak of the devil in conversation was to risk his manifestation, it was usual to substitute a euphemism such as *'Old Nick'*, *'Old Harry'* or *'Old Nobody'*. It might be that this pin was worn by members of a club of self-styled reprobates, *'Children of the Devil'*.

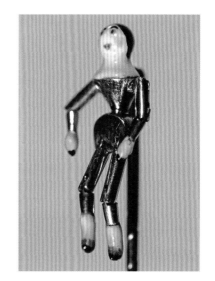

▲ **FIG 214** A tie pin in the form of an articulated doll in high carat rose gold with French opaque enamel head, hands and feet, c.1925.

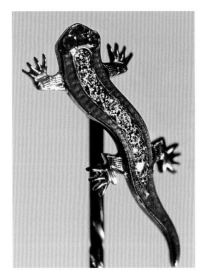

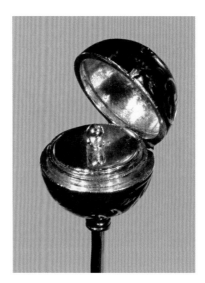

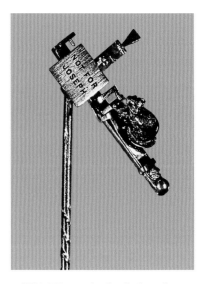

▲ **FIG 215** A delicate salamander tie pin in high carat gold, with eight diamonds inset from head to tail and green transparent enamel over a guilloché pattern down each side. The eyes are rose cut rubies, c.1910.

▲ **FIG 216** Tie pin in the form of a hinged sphere in niello and gold with an internal lid.

▲ **FIG 217** Tie pin - head in the form of a mouse evading an articulated trap with a caption *'Not for Joseph'*. Phrase in common use in the West Country about 1820 meaning 'not if I know it'. May be associated with St. Joseph who is traditionally supposed to have made mousetraps.

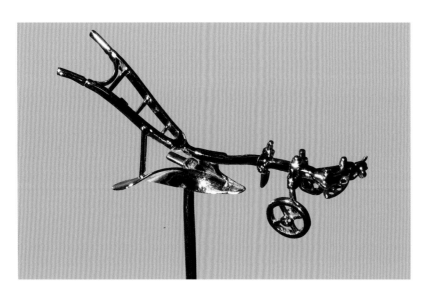

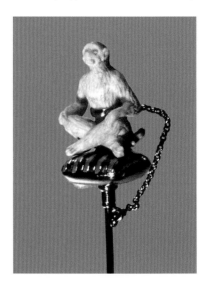

▲ **FIG 218** An 18ct gold tie pin in the form of an early farming plough, in considerable detail, with articulated wheels.

▲ **FIG 219** Tie pin representing a monkey god or king sitting on a cushion, showing strength, loyalty, good fortune and protection. The monkey is in ivory, showing incorruptibility; stripes on the cushion depict blue for the sky and red for the earth.

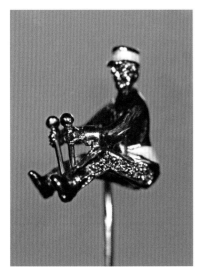

▲ **FIG 220** Tie pin - steam car driver with red guilloché enamel jacket and white trousers with diamonds, c.1890.

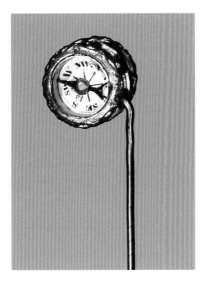

▲ **FIG 221** Tie pin in the form of a drum, with a compass on the front and a seal on the back.

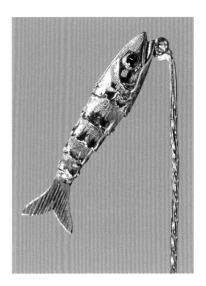

▲ **FIG 222** Tie pin in the form of an articulated fish which moves when worn; superb craftsmanship but almost impossible to repair if damaged. Regarded as a symbol for abundance and riches, but by the Japanese for endurance and courage.

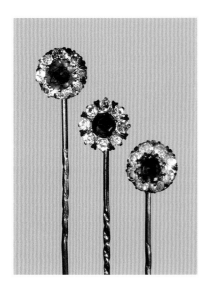

▲ **FIG 223** Three paste tie pins with detachable heads, usually sold in sets: sapphire, emerald and ruby colour, surrounded with clear paste to simulate diamonds.

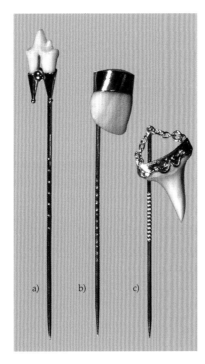

a) b) c)

◄ **FIG 224** Three pins of various animal teeth, perhaps a tourist or sporting item:

a) a fox or dog tooth set in gold,

b) camel tooth set in silver and

c) fish tooth set in gold with engraved decoration.

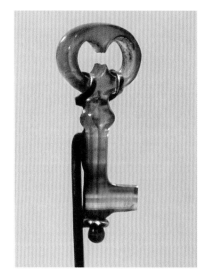

▲ FIG 225 Tie pin in the shape of a key made from banded agate, perhaps as a 21st birthday gift. As a talisman, a key was worn to induce foresight, prudence and good judgement, or a love token for the key to my heart.

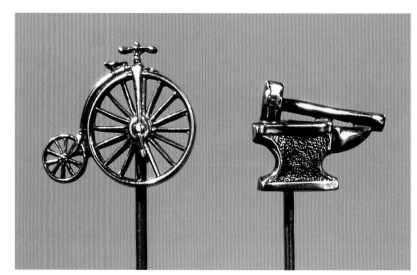

▲ FIG 226 Two silver castings as tie pins – an anvil and hammer together with a penny-farthing bicycle.

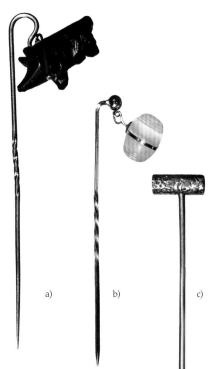

◀ FIG 227 Tie pins – three Stanhopes or *'peepers'* - the Stanhope is a small lens with a transparent photograph fixed at one end. When this is held up to the light, the photograph is greatly magnified:

a) Bog oak pig entitled *'a memory of Chester'* with six views, c.1890.

b) Souvenir of the descent of Annie Taylor, a 61 year old teacher, in a barrel over the Niagara Falls in 1901, the barrel is made of satinspar.

c) Silver croquet mallet showing a naked woman with a penny whistle, c.1880.

a) b) c)

▲ FIG 228 Microscope detail of the microdot in the silver croquet mallet tie pin, (FIG 227c).

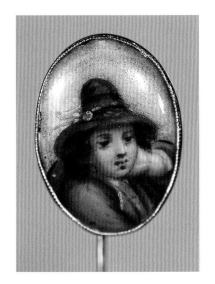

▲ **FIG 231** A tourist memento of an enamelled tie pin of an Alpine peasant.

▲ **FIG 232** A tie pin with monkey motif, with ruby eyes. In Far Eastern art, monkeys signify wisdom and detachment from worldly things. Those born under the sign of the monkey were adept in the arts, equitable, cheerful and universally regarded with affection.

▲ **FIG 233** Tie pin in flower design with engraved ornaments and inlay in two-coloured gold, red for the flower and green for leaves. Gold alloys used in jewellery are described by carat and colour. By alloying gold with other metals a wide range of colours may be produced, for example: red; yellow; green; purple; blue and white.

▲ **FIG 229** Tie pin as an enamelled King of Hearts playing card, given as a love token.

▲ **FIG 234** Enamelled tie pin in the form of masked, young woman with diamond eyes. c.1900.

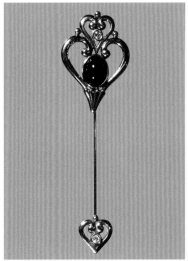

▲ **FIG 235** Luckenbooth tie pin made in gilt metal with black and clear paste stones. This is a style of Scottish jewellery of medieval origin. It is heart-shaped in design as a love token. The name is taken from the Luckenbooths that were street stalls near St Giles in Edinburgh.

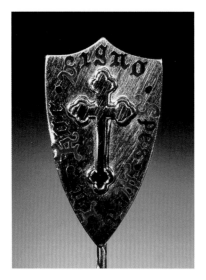

▲ **FIG 236** A shield-shaped tie pin showing a Christian symbol with the words *'In hoc signo spes mea'* - *'In this sign is my hope'*.

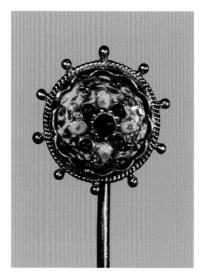

▲ **FIG 239** Modern French tie pin with *'crab'* mark with red paste stones and enamel using foil to enhance the colour, with an almandine garnet central stone. The *'crab mark'* was introduced in 1962 on silverware of low standards of fineness.

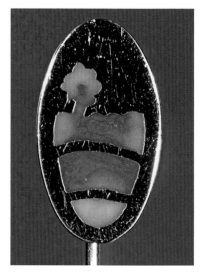

▲ **FIG 240** Tie pin - silver with resin inlay landscape scene, hallmarked London 1979 marked *'CJ'*.

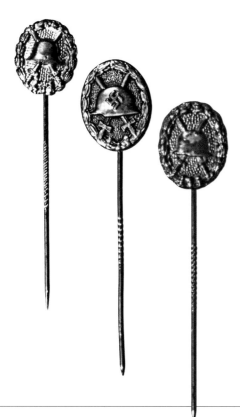

◄ **FIG 237** Tie pins - three German War Wound pins 1914-1918 and 1939-1945. These were usually made in three grades: gold, silver and bronze, and then presented according to the severity of the wound.

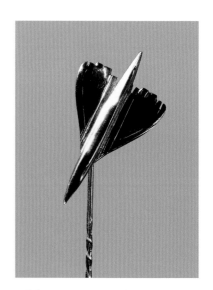

▲ **FIG 242** Tie pin model of the supersonic aircraft Concorde, 1969-2000, in 9ct gold with London hallmark, letter 'Q' for 1990, maker MJD, originally a flight memento.

CHAPTER 10

Tie Pin Presentation Boxes

The purchase of a tie pin was an important occasion and although the tie pin might vary in price from a few pence to many thousands of pounds, it was always a very special purchase. It was customary for the retailer to place the tie pin in a purpose-made box to suit the pin. Some boxes were covered in varnished paper to simulate leather. However, real green leather was favoured by Boucheron, varnished holly, birch or white maple wood by Fabergé, and gold-tooled leather by many other retailers.

The inside of the box lid was lined with coloured silk. The colours ranged from pale to deep shades, often with the name and address of the jeweller printed on it in elegant gold or black lettering. These printed names reveal retailers from Blackpool, Manchester, Gateshead-on-Tyne, Dublin, Bradford, Aberdeen and many more, which may, or may not, still be in existence. In London makers included R & S Garrard, 25 Haymarket; Longman & Strong'Th'Arm, Dover Street; and S J Phillips, 113 New Bond Street – the list is extensive. Boxes from Europe and America can occasionally be found, for example, Herman Brettschneider of Osnabrück, Henry Birks of Vancouver, Maison Americaine of Rouen. Here again, the list is almost endless.

The part of the box for holding the tie pin was made of coloured velvet with a groove and a small loop to hold the tie pin in place. This velvet may be restored by using sticky tape to gently touch the surface, in order to remove any marks or dust.

It is becoming increasingly difficult to buy tie pin boxes, as many dealers are reluctant to part with them and often mark them *'not for sale'*. However, it is not always the case and it is worth persevering and seeking out these treasures. They are beautifully made and the early ones are hand-carved in wood, finely proportioned, with gold tooling, and a catch that shuts with a *'snap'*. Strangely, genuine boxes made for Carl Fabergé appear to have the simple catch fixed upside down.

If damaged these boxes are not difficult to repair and usually only require glueing together, using elastic bands to hold the parts in place while the glue hardens. Care should be taken before polishing the box to ensure, with certainty, the nature of the covering used but for most, they will be transformed by using a small amount of appropriately coloured wax shoe polish and when dry, a gentle polish with a soft cloth. Then the box will be ready to protect or display a favourite tie pin.

◄ FIG 256
A rare example of a tie pin box made for G.P. Hart, Juwelier Den Haag to match the tie pin presented by Queen Emma of Waldeck. The Royal crown insignia is in gold tooling on the outside of the lid. Inside the lid is lined with pale cream silk and the base with deep red velvet. c.1925.

FIG 244 Three tie pin boxes ►
covering the early, middle and late Victorian periods.

▲ FIG 243 A very early cravat pin box hand-carved from wood.
It is covered in maroon paper to simulate leather and finished with a gold line, c.1830.

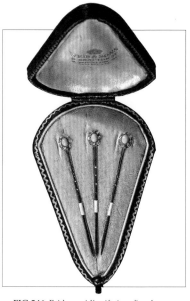

▲ FIG 246 Bridesmaid's gift, in a fitted case, dated 1906.

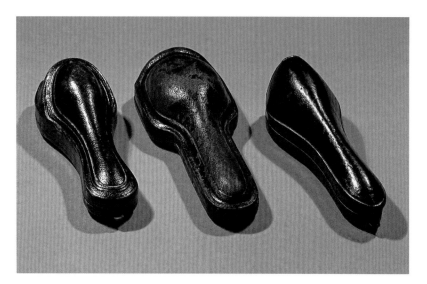

▲ FIG 245 Three moulded and shaped boxes popular in the late Victorian period.

FIG 252 Modern copies of Fabergé tie pin ▶ boxes, each containing a Fabergé pin.

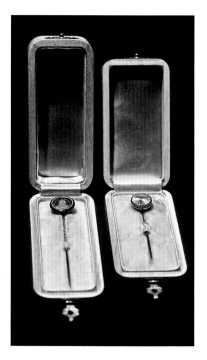

▲ **FIG 247** Three tie pin boxes covered in simulated leather material, with gold tooling and an elegant retail address inside each lid. c.1930, from the left Wynner & Co., S.J.Phillips and Richard Holt.

▲ **FIG 253** A tie pin box made for R & S Garrard & Co. in blue velvet with gold tooling c.1900 displaying a Royal tie pin.

▲ **FIG 254** The original tie pin box made for M. Rettie & Sons, Jewellers, Aberdeen in simulated maroon leather with gold lettering, for the memorial pin to John Brown. The lid is lined with deep blue silk and the base in dark blue velvet, c.1883.

▲ **FIG 248** Two unusual novelty tie pin boxes – the violin shape is probably continental. c.1930.

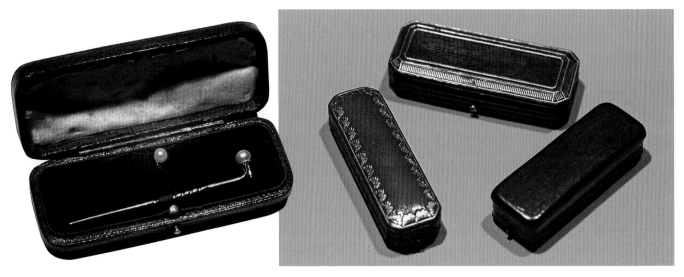

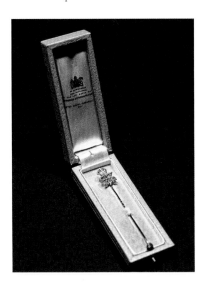

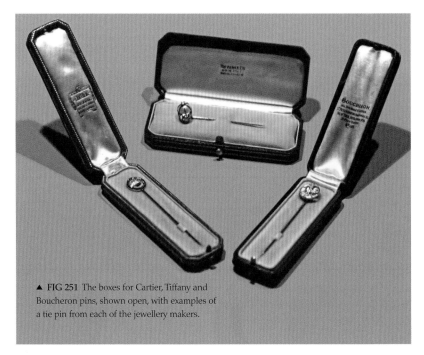

▲ FIG 249 A box containing a pearl tie pin and a pearl collar stud. This style of presentation case often contained a tie pin and three detachable heads, to simulate ruby, sapphire and emerald but made from paste. These stones were often set in a collar of clear paste to simulate diamonds.

▲ FIG 250 Three boxes made for Cartier, Tiffany and Boucheron tie pins.

▲ FIG 255 A tie pin box made for Longman & Strong'Th'Arm in simulated grey leather with gold tooling. The lid is lined with pale grey silk and the base in grey velvet, containing a Royal presentation pin c.1935.

▲ FIG 251 The boxes for Cartier, Tiffany and Boucheron pins, shown open, with examples of a tie pin from each of the jewellery makers.

CHAPTER 11

Places to explore and further your interest in Cravat and Tie Pins

There are not to my knowledge, any large collections of tie pins on public view in this country. In Paris however, there is a wonderful collection of tie pins by Boucheron in the Musée des Nissim de Camondo.

Several museums in London including the Victoria & Albert Museum, the British Museum, the Museum of London and in Birmingham the Museum and Art Gallery, usually include a small number of tie pins on display in their jewellery sections and some jewellery shops countrywide may have a small number of antique and modern pins to show, if you enquire.

The location of paintings of men or women wearing tie pins in detail is difficult to discover, as the tie pin is usually only a small dab of colour on a portrait. The National Portrait Gallery has a few late 19th Century and early 20th Century pictures showing men wearing tie pins, including Sir Edward Landseer and Charles Dickens. There is a painting of a Mrs Stevens in a riding habit, circa 1795, by Francis Wheatley (1747-1801) oil on canvas, in the Yale Center for British Art, Paul Mellon Collection, USA, that shows an ornamental pin on her shirt frill. At Bodelwyddan Castle, near Abergele, Clwyd there are a few paintings of men wearing tie pins. There are also portraits of Count d'Orsay and Lady Blessington.

It is suggested that contact be made before a visit if you wish to see a particular item, to ensure it is available.

In the Burlington Arcade in London there are several famous jewellery shops that have tie pins on display. Also there are jewellery establishments elsewhere in London that specialise in antique jewellery.

The antique *'super store'* in London is Grays Antique Hypermarket; this is an amazing consortium of specialist and helpful antique dealers who may have a few tie pins on display.

There are many prestigious Antique Fairs held around this country and overseas where dealers display tie pins but you may have to seek them out. There are several other places around the country that are worth searching in order to find out about these attractive and exquisite objects of jewellery. Antique magazines publish a countrywide monthly *'Fairs Calendar'* - this lists full details of both large and small fairs. Also listed is a monthly Diary of nation-wide antiques and jewellery auctions where interesting items can sometimes be found.

Many establishments, including auctioneers, now have their own website displaying items that are offered for sale. Many of these items are pictured and so can be seen before making contact if interested.

If you are a very early riser some areas hold early morning markets - these can be an excellent opportunity to handle, learn and maybe purchase a bargain. Another useful place can be the internet and also eBay, the on-line trading site. Sellers photograph or illustrate their items and usually produce a short description, together with price etc. However, some prior knowledge of history and gems is very useful here, as it is not possible to handle the object until it has been purchased *(caveat emptor)*!

Glossary

CASTING.

Metal may be melted and poured into a hollow mould which has been made to a required shape. The process is called 'casting'. The terms 'molten' and 'mould' can be compared to the way a jelly is poured into a specially shaped container.

ENAMELLING.

This is the technique of coating the surface of metal, usually silver, gold or copper, with high-quality glass that has been coloured by the addition of various metallic oxides.

After the powdered enamel has been applied to the metal, and when it is quite dry, it is heated to between 700°C to 850°C, depending on the colour, until the enamel melts and fuses onto the surface of the metal. The article should be allowed to cool, very slowly in an even temperature, to avoid cracking the enamel.

a) Basse-Taille. In this technique the surface of the metal is first engraved by hand, or machine, (engine turning), and covered with transparent enamel. After firing the design is visible through the transparent covering. Tie pins made by Carl Fabergé used this technique, and it is known as 'guilloché' enamel.

b) Champlevé. This technique is similar to Basse-Taille except the grooves of the design are filled with opaque enamel.

c) Cloisonné. This is a technique of decoration in which the design is outlined in wire, and with a high melting point solder the wires are attached to the back plate of the design.

The enclosures created are filled with coloured enamel, and then fired until the enamel has melted into the spaces created.

d) Limoges. The craftsmen, who created an enamelled art form in Limoges, France, used a technique of firing enamel over existing enamel. This produced a sculptured effect by laying semi-transparent white enamel over a dark background. If the white is varied in thickness, then it is possible to create a three-dimensional effect.

The use of white enamel on a background of red enamel was a popular combination for Limoges enamelling, but if the background was dark, (usually black), and covered with white enamel of varying thicknesses, the final, almost three-dimensional design is known as 'Grisaille' enamelling.

e) Painted. This is a technique where a flat, or slightly domed, metal surface is coated with white enamel and then a design painted onto the prepared surface with very fine enamel mixed with lavender oil or painting medium. It is, in a way, similar to water colour painting although the colours cannot be made by mixing but have to be individually produced. For this technique it is important to enamel the back of the metal in order for it to act as a counter-balancing coat (counter enamel) and prevent the metal from warping. Tie pins by William Essex and many others made frequent use of this technique.

Silver and gold foil may be applied to the enamelled surface and covered with transparent enamel. This gives a sparkling jewel-like quality to the design and highlights particular areas. Gemstones were also set into pictures to enrich the overall design.

f) Plique à jour. A technique of decoration in enamel in which the design is outlined in metal and the spaces created filled with transparent enamel but with no backing, so that after firing, the finished design has the appearance of a stained glass window. As plique à jour has no backing support it requires great skill in preparation. The powdered enamel should not be ground too finely and may be mixed with a little gum tragacanth before being packed into the spaces of the design. The enamel is supported by a mica sheet before heating and this is easily removed after the firing is completed. Plique à jour is extremely fragile and should be handled with great care.

This was a technique popular with the finest French jewellers in the Art Nouveau period and many tie pins were made. René Lalique (1860–1945) created a magnificent tie pin in the form of two cicadas facing each other, in pale green translucent plique à jour enamels, set with a gemstone.

GEMSTONE SHAPES

a) Brilliant cut. The most important style of cutting for transparent gemstones. The cut consists of 58 facets and was developed towards the end of the 17th Century. It is attributed to a Venetian lapidary – Vincenzio Peruzzi.

b) Cabochon. A style of gemstone cutting that has a smooth, domed top surface and flat back.

c) Eight-cut. A simplified modification of the brilliant cut form for small gemstones. The table, or top facet, of the gemstone is surrounded by eight four-sided facets. This cut is often used for inexpensive paste and marcasite jewellery.

d) Rose-cut A very old style of cutting for diamonds, other transparent stones and paste. It consists of a flat base and a dome of triangular facets, some 12 to 24 rising to a point. Deep red, pyrope, Bohemian garnets were cut in this style in the mid-Victorian period. Carl Fabergé often used rose cut diamonds, in a delicate and restrained manner, to highlight tiny points of interest, in his tie pins.

LAVA JEWELLERY

The area around Vesuvius has provided an abundance of *'lava'* – a soft delicate rock of various colours (commonly shades of brown) which carvers use to fashion cameos, intaglios and items in the round (three-dimensional) for the tourist trade.

However, they are not actually composed of lava, which would be far too friable, but an impure limestone which is recovered from the local rivers, lakes or dried up river beds. The name calcilutite has sometimes been applied to this rock which is a fine-grained limestone with subordinate material of silt or clay grade. It was a popular material for inexpensive jewellery in the mid to late 19th Century.

MASTIC

Mastic - an aromatic resin obtained from the mastic or lentisc tree, Pistacia lentiscus. This is an evergreen shrub of the cashew family and indigenous to the Mediterranean coastal region.

This resin and other similar materials have been used from ancient times, chiefly in the making of a pale varnish for protecting metals, wood and paintings. Its viscosity may be altered by using heat and a suitable solvent.

The colour of the resin may be changed by the addition of pigments similar to those used in painting. Soot was added to produce an intense black and used by Georgian jewellers in painting a black dot on the culet of a facetted gemstone to strengthen the internal reflection. A pitch-like paint was also used in a similar fashion.

NIELLO.

(from Medieval Latin *Nigellum* for black or dark coloured).

This is a grey/black semi-metallic alloy of copper, silver, lead and sulphur which has a low melting point (440° to 560° depending on its composition). It may be fused into cavities or lines previously engraved on the surface of gold or silver work. After removing any surplus, the lines show up black against the polished gold or silver background. This method of decoration has been used since ancient times and is sometimes referred to as Tula work from the name of a Russian town.

PASTE

A term used to show that a substitute for a gem stone has been made of glass. The term *'paste'* comes from the Italian word for *'dough'* but may well refer to the initial state of the glass paste before it is fused in the kiln. The simplest method of identification is to use a hand lens and look for bubbles and swirls as if the inside of the stone has been stirred.

RUFF

A ruff was a stiffly starched, fluted or pleated collar of lawn, muslin or other fine fabric, worn by men and women in the 15th, 16th and 17th Centuries.

The ruff was made from a single length of cloth pressed or 'goffered' into narrow pleats to form the collar. The shaping was carried out by the use of a heated goffering iron. Large numbers of small dress pins were then used to hold the ruff in place.

The goffering iron was like a hollow metal test-tube set horizontally on a stand. This tube was heated by inserting a very hot metal poker. The material for the collar could then be curled around the metal tube (goffering iron) to achieve the desired fluted shape.

RUSSIAN HALLMARKS
(MOST CITIES HAD THEIR OWN MARKS)

19TH CENTURY (UNTIL 1899)

MOSCOW
This hallmark consists of St. George and the dragon, with metal standard, Assay Master mark, date and the mark of the maker.

ST. PETERSBURG
This hallmark consists of crossed anchors and a sceptre (often looks like a windmill) with the metal standard, Assay Master mark, date and the mark of the maker.

1899–1908
In 1896 a new system of marking was introduced, known as the *"Kokoshnik"* mark or the profile of a woman, looking left and wearing a linen head dress called a Kokoshnik. The new system was not fully implemented until 1899.

1908–1917
There was a further change in 1908 when the female head was turned to the right.

STANDARDS FOR PRECIOUS METALS

The standard for silver and gold is measured in zolotniks, with 96 zolotniks corresponding to pure silver or 24 carat gold.

Gold 56 zolotniks = 14 ct
72 zolotniks = 18 ct
88 zolotniks = 22 ct

Silver 84 zolotniks = 875 parts per 1000
88 zolotniks = 916 parts per 1000
91 zolotniks = 947 parts per 1000
(British Sterling Silver Standard
925 parts per 1000)

SHEEP'S WOOL

Many memorial pins have a stylised image painted in sepia water colour on an ivory or bone plaque and covered by a glass dome.

To keep the plaque tight against the glass a small tuft of natural, unwashed sheep's wool is placed behind the picture to act as a natural spring and hold the ivory or bone in place.

SILHOUETTES

An art form that produces an outline, usually a person's profile, on paper, the profile is then reduced and the image filled in with black or another solid colour. It was a popular activity during the 18th and 19th Centuries when cut or painted profiles were presented in black on white.

The term was satirically derived from the name of Monsieur Etienne de Silhouette (1709-1769) whose hobby was cutting paper portraits. This is an underestimated skill which is showing signs of a revival, and silhouettes are becoming very collectable.

STANHOPES

Tie pins that have '*Stanhopes*' or '*peepers*' as a feature are of great interest to the collector. They are often found in the form of a miniature barrel, a croquet mallet or miniature animals, and indeed in an almost bewildering list of novelties. Each one concealed a small plano convex cylindrical lens some 3mm in diameter and 8mm in length in order to magnify the microphotographic image. The lens was invented by Charles, 3rd Earl of Stanhope (1753-1816) who was a politician, scientist and inventor.

Then in 1851 Frederick Scott Archer produced a fine grain photographic image on a glass plate coated with sensitised collodian emulsion.

In 1852 John Benjamin Dancer (1812-1887) experimented with the collodian process and produced tiny images which could be magnified without losing definition when projected onto a screen by using a '*magic lantern*' (an early form of Victorian slide projector). These microphotographs were also placed on the flat face of a Stanhope lens, and when the lens was held up to a light source and viewed from the convex face, the image appeared greatly magnified.

Copies of Dancer's microphotographic slides of paintings of the Royal Family by Winterhalter were presented to Queen Victoria and Prince Albert. Dancer also gave his friend Sir David Brewster a set of slide-mounted photographs. Then towards the end of 1856 Brewer exhibited the slides to the nobility of France and Italy. It is also believed that he visited the celebrated jeweller Fortunato Castellani and suggested that the microphotographs could be placed on colourless topaz or quartz gemstones, using the cut stones as a form of lens to magnify the image. Significantly, on his way back to England Sir David showed the slides to members of the French Scientific Circle in Paris.

In 1859 a Parisian photographer René Dagron, obtained a patent No 41361 for his microphotographic process, and his company dominated the production of microphotographic images for tourist novelties, and also equipment for the production of Stanhope lenses and microphotographs. He applied this technique to jewellery and other novelties and enjoyed considerable financial success. Among his many novelties were included gentlemen's *'breast pins'*.

The process was used by Dagron during the Franco-Prussian War of 1870 when microfilmed messages were transported by carrier pigeon during the siege of Paris.

The discovery of photomicrography allowed the creation of minute transparent photographs of tourist resorts, exhibitions, famous events and people - a seemingly endless list. *(Full details of this topic are to be found in 'Stanhopes' by Jean Scott).* Harder to find are elegant single or groups of young ladies in various states of undress.

WORK HARDENING OF METALS

Like most metals, gold and silver become harder and more difficult to shape the more they are bent and twisted. Over-bending or twisting leads to cracking and this is caused by the distortion of the crystalline structure of the metal.

To overcome this it is necessary to soften the metal by annealing. The metal to be annealed is heated to between 650°C to 700°C then quenched in water, or allowed to cool to a specific temperature before being quenched. This is a very critical operation and involves considerable professional expertise.

The various characteristics of the different gold and silver grades need to be considered before using heat.

Great care must be used when attempting to straighten the shank of a tie pin, as, if it has become very hard, it is easily broken.

Bibliography

Airne, C.W. *The Story of History series 1 – 5.* Thomas Hope & Sankey-Hudson Ltd.

Anstey, Christopher. *1766 The New Bath Guide.* Adams & Dart 1970.

Ashton, T.S. *The Industrial Revolution 1760–1830.* OUP 1949.

Baker, Keith. *British Arts and Crafts Jewellery.* Antique Collecting, November 1991.

Becker, Vivienne. *Antique and Twentieth Century Jewellery.* NAG Press 1987.

Becker, Vivienne. *Art Nouveau Jewellery.* Thames and Hudson 1985.

Bell, C. Jeanenne. *Hairwork Jewellery.* Schroeders 1998.

Benjamin, John. *Antique Jewellery.* Antique Collectors' Club 2003.

Bennett, David and Massetti, Daniela. *Understanding Jewellery.* Antique Collectors' Club 1994.

Blackmantle, B. *The English Spy.* Sherwood, Jones and Co. 1825.

Bracegirdle, B. and McCormick, J.B. *The Microscopic Photographs of J.B.Dancer.* Science Heritage. USA 1993.

Bradbury's *Book of Hallmarks.* Frederick Bradbury 2008.

Bradford, Ernle. *Four Centuries of European Jewellery.* Spring Books 1953.

Brailsford, J.W. *Later Prehistoric Antiquities of the British Isles.* The British Museum 1953.

Burgess, Fred W. *Antique Jewellery and Trinkets, 1919*

Bury, Shirley. *Jewellery Vol. I and Vol. II.* Antique Collectors' Club.

Bury, Shirley. *Sentimental Jewellery.* HMSO 1985.

Byrde, Penelope. *The Male Image. Men's Fashion in England 1300–1970.* B.T.Batsford 1979.

Carlyle, Jane Welsh. *New Selection of Letters* arranged by Trudy Bliss. Victor Gollancz 1949.

Chevalier, Jean and Gheerbrant, Alan. *Penguin Dictionary of Symbols. Translated by John Buchanan-Brow.* Penguin Books 1982.

Cicada Films. *Secrets of the Sands.* TV Channel 4 on 18 November 2002.

Clifford, Ann. *Cut Steel and Berlin Iron Jewellery.* Adams and Dart 1971.

Colle, Doriece. *Collars, Stocks, Cravats.* White Lion Publishers 1974.

Cooper, Diana and Battershill, Norman. *Victorian Sentimental Jewellery.* David and Charles 1972.

Cunnington, C. Willett and Cunnington, Phillis. *Handbook of English Costume in the 18th Century.* Faber and Faber 1972 (Revised Edition).

Cunnington, C. Willett and Cunnington, Phillis. *Handbook of English Costume in the 19th Century.* Faber and Faber 1970 (3rd Edition).

Dawes and Davidov. *Victorian Jewelry.*
Abbeville Press 1991.

Dawes, G. R. and Collings, O. *Georgian Jewellery.*
Antique Collectors' Club 2007.

Dickens, Charles. *The Pickwick Papers.* 1836.

Dickens, Charles. *Dombey and Son.* 1848.

Divis, Jan. *Silver Marks of the World.*
Hamlyn, London 1976.

Duncan, Alastair. *Art Nouveau Designers at
The Paris Salons (Two volumes)* Antique Collectors' Club
1994.

Eckstein and Firkin. *Gentlemen's Dress Accessories
(No. 205).* Shire Ltd.

Egan, Geoff and Pritchard, Francis.
Dress Accessories c.1150-c.1450. London HMSO.

Épingles de Cravate at Musée Des Arts Décoratifs.
1992. Collection of Boucheron Tie Pins.

Fales, Martha Gandy. *Jewellery in America 1600–1900.*
Antique Collectors' Club 1995.

Falk, Fritz. *Art Nouveau Jewellery from Pforzheim.*
Arnoldsche 2008.

Fink, Thomas and Yong Mao.
The 85 Ways to Tie a Tie. Fourth Estate 1999.

Flower, Margaret. *Victorian Jewellery.* Cassell 1951.

Forsyth, Hazel. *The Cheapside Hoard. London's Lost
Jewels.* 2013. Museum of London, PWP.

Foskett, Daphne. *Miniatures.* Antique Collectors' Club
1987.

Fox-Dawes, Charles. *Complete Guide to Heraldry.*
Wordsworth Reference 1996.

Gabriel Jeanette Hanisee. *The Gilbert Collection
Micromosaics.* Philip Wilson 2000.

Gabriel, Jüri. *Victoriana.* Hamlyn 1969.

Gainster, David and Stamper, Paul. (Editors).
*The Age of Transition – The Archaeology of English
Culture 1400–1600.* Section on Pins by Hazel Forsyth.
Oxbow Books 1997.

Gemstones. The Natural History Museum London.
2001.

Gere, Charlotte. *European and American Jewellery
1830–1914.* Heinemann 1975.

Gere, Charlotte. *Victorian Jewellery Design.*
William Kimber 1972.

Gere, Charlotte and Munn, Geoffrey. *Pre-Raphaelite
to Arts and Crafts Jewellery.* Antique Collectors' Club
1996.

Gere, Charlotte and Rudoe, Judy. *Jewellery in the Age
of Queen Victoria* The British Museum Press 2010.

Gibbings, Sarah. *The Tie – Trends and Traditions.*
Studio Editions.

Gill, Margaret A.V. *Tunbridge Ware. (No. 130).*
Shire Ltd 1997.

Gosling, J.G. *The Cheapside Hoard Confusion.*
The Gemmological Association of Great Britain, Vol 4
No 2 1995.

Gosling, J.G. and Morgan, A.D. *Berlin Ironwork.*
The Gemmological Association of Great Britain and
Society of Jewellery Historians, Gem and Jewellery
News 2004 Vol 13 No 3. First published as a shortened
version in GA Midlands Focus 2004.

Grasser, Walter and Hemmerle Franz.
Kosbare Krawallennadeln. Presten Munchen 1999.

Great Exhibition Catalogue. London 1851.

Grego, J. *R.H.Granow's Reminiscences.* 1900.

Guitant, Caroline de. *Fabergé in The Royal Collection.* Royal Collection Enterprises 2003.

Habsburg, Geza von. *Fabergé in America.* Thames and Hudson 1996.

Hart , Avril. *Ties.* Victoria and Albert Museum. 1998.

Heneage, Thomas. *The Belle Epoque of French Jewellery 1850–1910.* London 1990.

Hinks, Peter. *Victorian Jewellery.* Studio Editions 1991.

Hinks, Peter. *Nineteenth Century Jewellery.* Faber and Faber 1975.

Hoffman, Julius jr. *The Modern Style 1899–1905.* Arnoldsche 2006.

Houtzager, Guus. *The Complete Encyclopedia of Greek Mythology.* Rebo International. 2003.

Hudson, Roger (Editor). *The Grand Tour 1592–1796.* The Folio Society 1993.

Hue-Williams, Sarah. *Christie's Guide to Jewellery.* Assouline 2001.

Hughes, G. Bernard. *Sporting Scarf Pins.* Country Life, February 1952.

Hughes, Graham. *Modern Jewellery 1890–1964.* Studio Vista 1964.

Hull Grundy Gift *The Art of the Jeweller A Catalogue of the Hull Grundy Gift to the British Museum.* 1984.

Hunt, Jonathan. *Pin Makers to the World.* James and James 1989.

Hunter, Margaret. *Mourning Jewellery.* Costume Society of Scotland 1993.

Jackson's *Hallmarks.* Ed. Ian Pickford. Antique Collectors' Club.

Jesse, Captain. *The Life of Beau Brummell.* Two volumes London 1844. Navaire Society 1927.

Jull, Douglas. *Collecting Stanhopes.* D.S. Publications Worthing 1997.

Karlin, Elyse Zorn. *Jewellery and Metalwork in the Arts and Crafts Tradition.* Schiffer PA 2004.

Kelly, Ian. *Beau Brummell – The Ultimate Dandy.* Hodder & Stoughton 2005.

Kerins, Jack and Elynore. *Stickpins.* Collector Books, USA 1995.

Lamont-Brown, Raymond. *John Brown.* Sutton Publishing Ltd 2000.

Lamprecht Collection of Cast Iron Art. American Cast Iron Pipe Co. 1941.

Lewis, M.D.S. *Antique Paste Jewellery.* Faber and Faber 1970.

Longman, E.D. and Loch, S. *Pins and Pincushions.* Longman-Green & Co. 1911.

Luthi, Anne Louise. *Sentimental Jewellery.* Shire Ltd 1998.

Maryon, Herbert. *Metalwork and Enamelling (section on twists).* Chapman & Hall 1959.

Massinella, Anna Maria. *The Gilbert Collection Hardstones.* Philip Wilson 2000.

Matthews, Mrs. (1838) *Memoirs of Charles Matthews 1809.* The Satirist 1808.

Meyer, Jonathan. *Great Exhibitions 1851–1900.* Antique Collectors' Club 2006.

Millenet, Louis-Eliè. *Enamelling on Metal 1927.*

Miller, Judith. *Arts & Crafts.* Dorling Kindersley 2003.

Miller Judith. *Costume Jewellery.* Dorling Kindersley 2003.

Miller, Judith. *Art Nouveau.* Dorling Kindersley 2004.

Moore, Tim. *Continental Drifter – Journal of Thomas Coryate 1608.* Abacus 2001.

Muller, Helen. *Jet Jewellery and Ornaments (No 52)* Shire Ltd 1980.

Munn, Geoffrey G. *Castellani and Giuliano.* Trefoil Books London 1984.

Murdoch, Tessa. *Treasures and Trinkets.* Museum of London 1991.

Nadelhoffer, Hans. *Cartier.* Thames & Hudson 1984.

Newman, Harold. *An Illustrated Dictionary of Jewellery.* Thames and Hudson 1981.

O'Day, Deirdre. *Victorian Jewellery.* Charles Letts 1974.

OED 1989 – under *'tie pin'* refers to a Travellers' Guide dated 1780. The original source was a booklet, a copy of which it has not been possible to trace. The reference was originally taken from an article in the Westminster Gazette, 2nd September (probably) 1895.

Pearsall, Ronald. *Sporting Pins.* Collectors' Guide June 1991.

Phillips, Clare. *Jewels and Jewellery.* V & A Publications 2000.

Pliny the Elder. *Historia Naturalis.* Books XXXVI and XXXVII. Translated by D.E.Eicholz.

Poynder, Michael. *Jewellery – Reference and Price Guide.* Antique Collectors' Club 2000.

Purcell, Katherine. *Falize. A Dynasty of Jewellery.* Thames and Hudson 1999.

Purcell, Katherine. *Fabergé and The Russian Jewellers.* Wartski 2006.

Raulet, Sylvie. *Art Deco Jewellery.* Thames and Hudson 1985.

Read, P.G. *Dictionary of Gemmology.* Butterworth 1982.

Rhodes, Alexandra M.R. *Hatpins and Tie Pins.* Lutterworth Press 1982.

Ribeiro, Aileen. *Dress in Eighteenth Century Europe.* Yale University Press 2002.

Ribeiro, Aileen. *The Gallery of Fashion.* National Portrait Gallery 2000.

Ritchie, Carson I. A. *Carving Shells and Cameos.* Arthur Baker, London 1970.

Ritchie, Carson I. A. *Ivory Carving.* Arthur Baker, London 1969.

Robinson, Tony. *The Worst Jobs in History.* Pan Books 2004.

Rowan, Michele. *Cameos – Nineteenth Century.* Antique Collectors' Club 2004.

Sala, George Augustus. *Twice Round the Clock.* 1859.

Sataloff, J. *Art Nouveau Jewellery.* Dorrance 1984.

Scarisbrick, Diana. *Jewellery in Britain 1066–1837.* Michael Russell 1994.

Scott, Jean. *Stanhopes.* Greenlight Publishing 2002.

Scott, Margaret. *A Visual History of Costume – The Fourteenth and Fifteenth Centuries.* Batsford.

Shirley and Shirley. *Handicraft in Metalwork.*
B.T.Batsford 1953.

Sinkankas, John. *Gem Cutting.* Van Nostrand
Reinhold 1955.

Smollett, Tobias. *The Adventures of Roderick Random*
1748.

Snowman, A Kenneth. *Fabergé: Lost and Found.*
Harry N Abrahams Inc 1993.

Snowman, A Kenneth. *The Master Jewellers.*
Thames and Hudson 1990.

Soros and Walker, *Castellani.* Yale University Press
2004.

Southgate, G. W. *English Economic History.*
J M Dent 1958.

Speight, Alexanna. *The Lock of Hair.* London 1871.

Stockdale, J. J. *Neckclothitania.* 1818.

Surtees, R. S. *Jorrock's Jaunts and Jollities* 1831.

Swift, Ellen. *Norman Dress Accessories.*
Shire Archaeology 2003.

Tait, Hugh. Editor. *7000 Years of Jewellery.*
British Museum Press 1986.

Tardy. *International Hallmarks on Silver.*

The Sayn Palace Museum Guide. 2014.

Thomas, William and Pavitt, Kate. *Book of Talismans,
Amulets and Zodiacal Gems.* William Rider & Son 1914.

Tunze, N.B. *Pictorial Art with Hard Stones – Pietre
Dure.* Norbert B Tunze 1998.

Untracht, Oppi. *Jewellery Concepts and Technology.*
Robert Hale, London 1982.

Untracht, Oppi. *Metal Techniques for Craftsmen.*
Robert Hale 1968.

Vever, Henri. *French Jewellery of the Nineteenth Century.*
Translated by Katherine Purcell. Thames and Hudson
2001.

Vilímková, Milada. *Egyptian Jewellery.* Hamlyn 1969.

Von Boehn, Max. *Modes and Manners – Ornaments.*
J.M.Dent 1929.

Von Boehn, Max. *Modes and Manners Volumes 1–1V.*
George G Harrap 1932.

Wallis, Keith. *Gemstones.* The Antique Collectors'
Club. 2006.

Warren, Geoffrey. *Fashion Accessories since 1500.*
Unwin Hyman 1987.

Watts, Geoffrey. *Russian Silversmiths' Hallmarks
1700-1917.* Gemini Publications 2006.

Webster, Robert. *Gems.* Newnes-Butterworth. 1975.

Webster, Robert. *Gemmologists Compendium.* NAG
Press 1998.

Whitfield, Niamh. *The Finding of the Tara Brooch.*
Journal of the Royal Society of Antiquaries of Ireland,
Volume 104, 1974.

Woodiwiss, John. *British Silhouettes.* Country Life
1965.

APPENDIX 1

Names associated with ornamental pins and some indication of their use

1) Cravat Pin		**2)** Stick Pin		**3)** Pin	

4) Tie Pin – 1780 Travellers' Guide mentioned a silver tie pin OED

5) Breast Pin	**6)** Lace Pin	**7)** Scarf Pin

8) Jabot Pin – similar to a tie pin worn on a jabot (ruffle worn on the front of a shirt or dress) - Scottish

9) Stock Pin	**10)** Kerchief Pin	**11)** Bib Pin
12) Shirt Pin	**13)** Coat Pin	**14)** Stick
15) Lapel Pin	**16)** Dress Pin	**17)** Shawl Pin

18) Sureté Pin – has a safety device that screws onto the end of the pin.

19) Brooch Pin	**20)** Collar Pin	**21)** Cloak Pin

22) Ascot Pin

APPENDIX 2

Index of References of Dress & Tie Pins in Literature

1) Tobias Smollett - Roderick Random (1748) Published J M Dent & Sons 1921
p.196 Description of Captain Whiffle's dress - *'brooch set with garnets'*

2) Henry Fielding - Tom Jones (1749) Novel giving social background.

3) Fanny Burney - Evelina (1778) Novel giving some social background.

4) Captain Gronow - Reminiscences and Recollections (1810-1860) Published John C. Nimmo 1892

Vol.I	p.90	Description of English dress in Paris 'a gigantic bunch of seals'
	p.161	Reference to Count D'Orsay
	p.276/281	Reference to Count d'Orsay
Vol.II	p.58	Description of Lord C….
	p.108	Reference to the *'Four-in-Hand' Club*

5) Bernard Blackmantle - The English Spy (1825) Published Sherwood, Jones and Co. 1825

Vol I p.131 *'everything useful to the value of a cloak pin'*
 p.169 Reference to Beau Brummell
 p.187 Description of a Dandy poem
Vol II p.326 *'Each lordly man his taper waist displays....'*

6) R S Surtees - Jorrock's Jaunts and Jollities (1831) Published by Methuen & Co.

 p. 96 'Three or four studs, butterfly brooch made of glass'
 p.119 'cream cravat....gold coach and four pin'

7) Charles Dickens - Pickwick Papers (1836)

 p.495 'A large diamond pin....shirt frill'

8) Mrs Mathews - Memoirs of Charles Mathews (1838) Published Richard Bentley 1838

Vol I Mathews' stock in trade as an actor including *stock buckles*
Vol II p112 *'Four-in-Hand' Club'* - description of dress and illustration
 p.161 *'The Jubilee Lozenge'* hoax - *'a trinket in the form of a short brooch'*
Vol III p.236 Reference to Count d'Orsay

9) Jane Welsh Carlyle - A selection of her letters (1839) Published by Victor Gollancz Ltd 1950

 p.83/4 Reference to Count d'Orsay
 p.159 Reference to *'breast pin'* and *'pearl breast pin'*
 p.165 Further reference to Count d'Orsay

10) William Thackeray - Vanity Fair (1847)

 Novel giving some social background

11) Charles Dickens - Dombey and Son (1848)

 p.165 *'Mr Toots was one blaze of jewellery and buttons...'*

12) George Augustus Sala - Twice round the Clock (1859) Published N Y Humanities Press 1971

 p. 19 *'Neckcloth fastened with horseshoe pin'*
 p. 65 *'cheap pins in their foul cravats'*
 p.134 reference to *'Nobody's Child'* Illustration of Regent's Street at 2 pm.
 p.194 Description of the dress of hangers on..... *'wearing horseshoe pins'*
 p.195 Description of City Dandy - Beau Brummell
 p.259 1852 - death of Count d'Orsay
 p.283 Description of Baron Nathan at the Opera - *'his diamond solitaire in his laced shirt frill'*
 p.288 Illustration - 10 pm at the Belvidere (bottom left - portly man with pin in his stock)
 p.311 Midnight in London - phantoms and the Devil
 p.320 The painted clown - *'mosaic jewellery and an astonishing cravat'*

James G. Gosling

James has been a keen member of the Gemmological Association of Great Britain since 1968 when he became an FGA with Distinction. He also took City & Guilds Courses in Jewellery and Enamelling at Harrow College of Art and was a member of the legendary Post-graduate Course held at Sir John Cass College, London, tutored by Alan Jobbins.

In his professional role he qualified as a teacher of Design & Technology at The University of London. He also pursued courses in Art & Design and studied Music at Trinity College of Music in London, where his violin teacher was Vera Kantrovitch. He has taught in schools, university and adult education. Before he retired he was Schools Inspector in Derbyshire and Wolverhampton and Chief Examiner for Teacher Training with the Universities of Birmingham, Coventry and Wolverhampton.

James carried out a project for The Overseas Development Administration to set up a Lapidary Industry for Guyana in South America, which involved travelling into the interior for raw materials and living with the Amerindians. He returned with some interesting new materials including Guyanese Agate and Black Pearls of Guyana. He has also written articles for the Journal of Gemmology, the Antique Collectors' Club and the Midland Focus.

James has had a life long interest in art and has a great love of drawing, watercolours and painting miniatures. He and his wife Elizabeth share a great interest in antiques, are members of The Society of Jewellery Historians and the Midlands Branch of The Gemmological Association. James is also on the Committee of the Friends of Wolverhampton Art Gallery and Museums.